Growing Up in
BURBANK

Growing Up in

BURBANK

Boomer Memories from The Akron to Zodys

Wesley H. Clark & Michael B. McDaniel

THE
History
PRESS

Published by The History Press
Charleston, SC
www.historypress.net

Front cover: Use of Johnny Carson Burbank poster courtesy of Carson Entertainment Group.

First published 2017

Manufactured in the United States

ISBN 9781625859860

Library of Congress Control Number: 2017948514

To all those who bought our previous book Lost Burbank
and enjoy our Burbankia *website*

Contents

Preface

Growing up happens in a heartbeat. One day you're in diapers, the next you're gone, but the memories of childhood stay with you for the long haul. I remember a time, a place, a particular Fourth of July, the things that happened in that decade of war and change. I remember a house like a lot of houses, a yard like a lot of yards, on a street like a lot of other streets. I remember how hard it was growing up among people and places I loved. Most of all, I remember how hard it was to leave. And the thing is, after all these years, I still look back in wonder.
—Kevin Arnold's final voiceover from The Wonder Years

The authors are fond of *The Wonder Years* not only because it takes place in Burbank, California (more on that in another chapter), but because in the episode set during the 1972 presidential election, the protagonist, Kevin, is described as being sixteen. That makes him exactly the authors' age. (We'll save you from doing the math: we were born in 1956.) *The Wonder Years*, then, serves as a narrative metaphor for our own lives.

And what years they were! We are certain that everyone of any era considers their formative years to be special, but ours, we think, were unique.

We feel blessed to have come of age in the affluent 1960s and 1970s. Our parents were members of what has come to be known as the "Greatest Generation," or the "G.I. Generation"—the people who lived during and fought in World War II. This also, inevitably, includes mention of the Great Depression. Talking to our parents about their younger years was often a matter of listening to how they endured tough times. They were children at a time when three square meals a day, a protective roof over one's head

What was on male Burbank High School students' minds after graduation? Military service. From the 1943 *Ceralbus* yearbook. *Burbank Historical Society*.

and a job were by no means assured things in America. For some, it seemed to be the end of American capitalism as a viable force for providing a good standard of living.

One of the formative experiences of our parents' generation was hearing the radio announcement of the bombing of Pearl Harbor by the Japanese; America was threatened in a very real way and directly felt the hand of war. Discussions with our parents also included food rationing, loved ones being away at war and, eventually, victory. But victory came with a certain and much-discussed national loss of innocence that even permeated the movies our parents watched. (A signal characteristic of postwar film noir, or crime films of the 1940s and 1950s, was of societal corruption and GIs returning to an environment that seemed to be at odds with the apple pie American way they had fought to preserve.)

But the 1930s and 1940s morphed into the 1950s, when we were born, and for many years the largest single generational group of Americans was composed of females born in 1957. The baby boom was on! Our generation was celebrated for being better educated and fed and in possession of more leisure time than ever before. Unlike our parents, we had pocket money, which we freely spent on comic books and the other things we desired. The marketplace acknowledged that a wholly new socio-generational entity came into being—the teenager—with his and her own interests, passions and consumer luxuries. Prior to this time, you were either a child or an adult, and a casual glance through old Burbank High *Ceralbus* yearbooks showed that older teens wanted to look, act and dress like adults. But when a frustrated Paul Lynde sang about "kids these days" in the musical *Bye Bye Birdie* (1963), he was expressing our parents' growing confusion and dismay with this new social force.

People often think of the 1950s as being a cheery, white bread and somewhat mindless decade for the young. America, presided over by a famously grinning President Eisenhower, saw the emergence of Elvis and the birth of rock 'n' roll. But if you dig a little deeper you find that the era of sock hops was also the era of *Rock Around the Clock* (which illustrated the blight of juvenile delinquency), the Red Menace, atomic annihilation and subversive literature from the beatnik culture. Children are always susceptible to scares and causes for anxiety: they recall parents discussing the drug problem and generational unrest in the 1960s. Boomers have vivid memories of news footage of the Berlin Wall being erected in 1961—that was scary, too.

Prior to the escalation of the Vietnam War, Baby Boomers were upbeat and excited by the announced coming of the space age or, as it was

sometimes called, the atomic age. But later on in the sixties, the Age of Aquarius became the hoped-for milestone—less science, more mysticism. (Google says that, astronomically speaking, the earth doesn't move into the Age of Aquarius until AD 2597. The songwriters were obviously getting ahead of themselves.) Whatever the new era was to be called, life was bound to be happier, and we were all looking forward to the day when we could zip around town in cars like those piloted by George Jetson. After all, many of us were discontented, mired in an era somewhere between that of the Flintstones and the Jetsons. But optimism was the prevailing view in the early sixties. By the time the late sixties arrived, we had seen the Kennedy assassinations (both JFK and RFK), the Martin Luther King assassination, Vietnam-related campus unrest, riots, the generation gap and Altamont. America seemed to be tearing itself apart at the seams. The year 1969 was decidedly less cheery than 1960.

But to a great extent, we were isolated in suburban Burbank, nestled comfortably among the Verdugo Hills. Ours was not an inner-city experience, and in our little stucco-covered homes, we felt like the problems seen on our television tubes were other people's issues, not ours. We were young, and life was easy, casual and idyllic. The patio culture beckoned, and the gentle weather and the low-key, informal Southern California atmosphere helped make growing up less traumatic.

A shameless plug: If you would understand the unique Southern California community of Burbank—a land of "People, Pride and Progress" (a city motto in vogue when we were kids)—it helps to read our previous work *Lost Burbank* (2016, The History Press). As of this writing, it's available via amazon.com or, if you're a townie, through the Burbank Public Library system. The authors were delighted and a bit stupefied to learn that it could also be found in the Burbank Costco. In *Lost Burbank*, we discuss some introductory history of the place, and you can read more details and much more local lore. It provides a complete setting for what follows in this book of Boomer memories.

It is our wish that these pages transport you back. If perchance some sentence or reference causes you to zone out and recall things you had not thought about for decades, all the better. You thereby become a participant in the flow of the book.

Enjoy!

Wes Clark and Mike McDaniel
Spring 2017

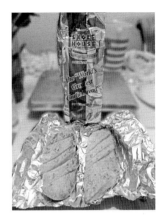

Smoke House garlic bread, a Burbank treat. Over twenty-two million loaves sold since 1946. *Mike McDaniel.*

Cautionary note: While the Baby Boomer generation (those born approximately between 1946 and 1964) is commonly referred to as being monolithic, it wasn't. Some observers more realistically classify it into two cohorts, a sort of older siblings and younger siblings kind of thing. The older cohort fought and protested Vietnam. They tended to be more revolutionary and daring in outlook. They experimented with drugs far more often. The younger and somewhat more traditional cohort, which the authors belong to, often looked on and wondered what on earth was going on with their older siblings (or, since the authors themselves were both only children, their *friends'* older siblings).

This being the case, much of the outlook of this book will necessarily be focused on the experiences and viewpoints of the younger Boomer cohort.

Acknowledgements

As was the case with *Lost Burbank*, our first book about our hometown, many fine people contributed and must be noted. Laurie Krill, our wonderful acquisitions editor at The History Press, helped with the proposal process and provided constant help and encouragement on this book; Abigail Fleming was our treasured copy editor. Wes's wife, Cari Clark, provided critical readings, editing and commentary. Since she was popular in high school and understood cliques better than we did, she helped out with the various definitions for surfers, band kids and so on. This book is far better than it would have been without her involvement.

Via interviews with others, our pal Rob Avery took time off from writing Sim Greene mystery novels to provide the "Hooligans" chapter text; thank you! Mike Toon also provided great stories. Our dear friends Dreamy Gal Pal Angela DeTolla Smythe and Viki Lynne (Gardemann) Yonan contributed thoughts captured in this book. So did that walking ball of Bulldog enthusiasm Corey Fredrickson. We love you, man! Thanks also to Rose Caven Piazza, Mike Kurthy, Harrod Blank and George Marciniw, who provided photos.

Sue Baldaseroni, Penny Strickland Rivera and Betty Penrod at the Burbank Historical Society were a pleasure to work with, just as they were with our *Lost Burbank* book. Seriously, if you have the least bit of interest in Burbank history you owe these folks a visit. The Gordon R. Howard Museum on 115 Lomita Street is very fine.

Douglas White, Michael Reighley, W. Martin, Len Osterberg, Jim Peel, Jim Voigt, Arnold McMunn and Julie Grimm Gregg contributed fun stories that originally appeared on the *Burbankia* site's "Burbankers Remember" article. Thank you!

A special thanks and recognition goes to the great folks on the "You know you're from Burbank if..." Facebook group, in no particular order: Shel Weisbach, Bob Marak, Dodie Moore, Bob Thomasson, Jeri Morin Valencia, Duane Thaxton, Shari Boyd, Deborah Johnson, Peggy Peters, James McGillis, Chuck Herron, Cathy Coyle, Margy Lillibridge, Judith Houver, Peggy Melton Cyphers, Tim Chamberlain, Rich Halliburton, Patti Steele Hallowes, Larry Levine, Jack Chavoor, Sharon Smestad Burke, Jonathan Doe, Anita LeMaster Kranzberg, Dianne Postal-Simmons, Buena Joshi, Roger Lee Pickup, Nadine Aguirre Lujan, Barry Burnett, Gregory Thompson, Paul Hall, Priscilla Griffin Shacklett, Kathleen Wyatt Richardson, Tom Moriarity, Paul Bittick, Pam Kirkwood, Tony Trotta, Mundo Bravo, Rick Moran, Carol Nicholls Lebrecht, Mike King, Virginia Gockel, Connie Barron Trimble, Les Heller, Marie Martin, Lou Schutte, Rick Watts, Mike Arredondo, Ronna Payne, Patrick Thompson, Raymond Christopher, Marvin Steinberg and Don Ray. These folks shared information, images and stories and helped with fact-checking—it wouldn't be a good Baby Boomer book without them. This particular Facebook group is an excellent resource about all things Burbank, by the way. Have a Burbank mystery? Ask about it there.

1
Beautiful Downtown Burbank

This chapter is a capsule introductory description of the place we call our hometown and why, live where we will in our golden years, we cannot refrain from insisting that our hometown is still Burbank. We will flesh out the Boomer memories associated with growing up in Burbank in later chapters.

EARLY BURBANK

Many people begin nodding off when history is mentioned. It is our pet theory that people can be classified into three groups: (1) Those who are absolutely obsessed about the past, (2) Those who live mainly in the present and worry not about the future or care about the past and (3) Those who describe compelling visions of the future—futurists. Clearly, we are in the first category, hence this book. Perhaps you are one of those, too.

Growing up, it was sometimes a surprise for we modern Americans to learn that the place we call home was called home for thousands or tens of thousands of years prior to our arrival by people who left their mark buried in the soil, perhaps to be rediscovered via archaeology. Those Burbankers experienced childhood, knew parents and, later, had lovers, created families, raised same and died. Along the way, they did what they could to survive and advance the civilization they knew. Sometimes they came into conflict with others in the area. Most likely their lives were, in

the words of Thomas Hobbes, "solitary, poor, nasty, brutish, and short." Hobbes also described mankind's natural state as "warre of every man against every man." It's difficult to envision that our placid town was ever such a battlefield, but it's a fact that one of the oldest artifacts we have of ancient Burbank life was discovered by an antiquities collector named Paul Knapp, who found an arrowhead wedged in the skull of an ancient Burbanker in a tree stump along Buena Vista Street. Burbank's first murder! The stories of these unfortunates are untold. A pity, for who's to say that only Baby Boomers should document their ordinary lives to the degree to which we've become accustomed?

An undated and unpublished image of Dr. David Burbank (holding pole), his wife, Clara, and daughter Flora Burbank Griffin (in white) in Geyser Springs, California, 1880s. *Burbank Historical Society.*

Certainly, when we were teens taking the mandatory California history class, it seemed that after a cursory description of Indians (now called Native Americans), Burbank history began with the Spanish. After some mention of ranchos, the Verdugo family (who gave their name to the gentle hills seen in Burbank) and strife between Pio Pico and Manuel Micheltorena, which resulted in the totally underwhelming 1845 Battle of La Providencia (total casualties: one beheaded mule), the Anglo-Saxon Americans aggressively strode onto the scene. Emboldened with notions of Manifest Destiny and a natural conquering spirit (which is a heroic way of saying pushiness), they bought and finagled land and soon became the main players in Burbank.

This leads us to Dr. David Emory Burbank, a dentist from New Hampshire with deep-set blue eyes who exchanged removing molars and bicuspids in San Francisco for ranching and sheep shearing along the Los Angeles River. Ignore anything you hear from the History Channel about the celebrated botanist Luther Burbank giving his name to the place. It was Dr. David Burbank.

In the spirit of 1880s-era boosterism and profit, Burbank was extensively praised and advertised as being a fine place to settle, with a bounteous climate and youth-giving characteristics. Here's some fulsome praise from an 1889 article in the *Burbank Times*: "Burbank is just 18 miles from the Pacific Ocean, just close enough to catch the breezes of summer to moderate the temperature and cause that balminess so vital to persons in ill health, especially those afflicted with bronchial and pulmonary complaints." Baby Boomers will find this especially amusing. We all knew that, in the summer, the San Fernando Valley was hotter than other parts of Los Angeles, and those afflicted with bronchial complaints were made more miserable by LA's legendary smog. So let's fast forward to the era more relevant to us.

THE BOOMERS' BURBANK

A global event of shattering historic proportions—World War II— changed Burbank from a mixed residential/agricultural/industrial center to the residential/industrial society we knew as kids. Other than parkland, the only fields we knew were the numerous vacant lots that blighted Burbank, and the only agricultural products of those were weeds, some of which produced stickers that made life hell for Schwinn Sting-Ray tires, causing punctures. (The problem of too many vacant lots in town was so pronounced that *Rowan and Martin's Laugh-In* once did a satirical piece

wherein announcer Gary Owens intoned, "THIS IS BEAUTIFUL DOWNTOWN BURBANK," and Eve Arden enthusiastically extolled the virtues of BDB's many "historic" vacant lots.)

Our generation is called Baby Boomers due to the social changes wrought by World War II, namely, returning GIs buying homes and starting families. America before the war was a vastly different place than the America that grew out of the conflict became (just watch some old *Our Gang* comedies, where Culver City kids are used to playing with mules and coexisting with chickens). We are still experiencing the reverberations of that war. But it is a matter of some amazement to the authors that, as late as 1967, the last winery in town (Brusso) closed, in the very same era when the Lockheed Aircraft Corporation was building the world's most technologically advanced spy plane (the SR-71 Blackbird) and developing the world's most technologically advanced passenger aircraft (the L-1011 TriStar).

Growing up in Burbank, we were all aware that we were a company town for NBC, Disney and Warner Bros. (and, to a lesser extent, Columbia Pictures), and as time passed, the city fathers, like their 1880s counterparts, found their promotional angle when they realized that Burbank wasn't just a major media capital—it was really Hollywood. That is, there was just as much, if not more, entertainment produced in Burbank than in Hollywood. And by the time the sixties arrived, the term *Hollywood* had started to become an abstraction anyway. When we Boomers were growing up, Hollywood the city seemed old and shabby. Its star-studded and fabled walkway, Hollywood Boulevard, was rife with strip clubs and sleaze. (Since Wes Clark had a boyhood pal who lived just behind the Egyptian Theater, he noticed the evidence of decay whenever his mom allowed a Hollywood sleepover.) In complete contrast, in 1967, we Burbankers had the brand-new pedestrian-only Golden Mall with bubbling fountains and beautiful landscaped islands as our centerpiece. And we weren't fooled. In 1972, Johnny Carson moved *The Tonight Show* into the NBC Studios in town to avail himself of celebrities filming nearby looking to plug their latest films. Whenever Ed McMahon began his introductory voiceover with "From Hollywood," we knew he really meant "From BURBANK."

How did this affect us? We had pride. Burbank was obviously an up-and-coming place favored by weather, situation, economics and the presence of celebrities. (Bob Hope, then considered America's most honored humorist, was a noted Toluca Lake resident. And Johnny Carson moved in from no less a place than New York City.) This pride was evident whether we were hillside Burbankers (professionals and semiprofessionals living in large

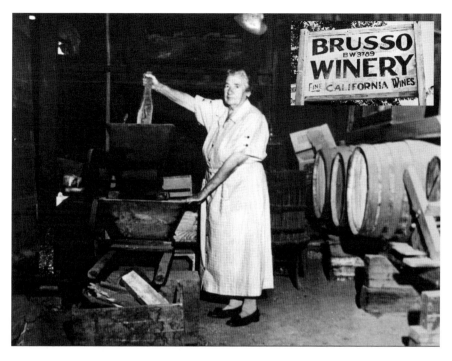

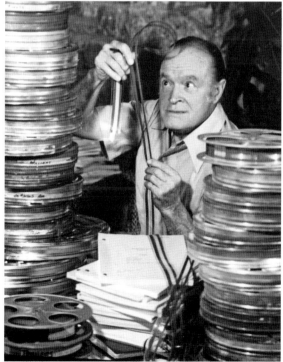

Above: Mrs. Brusso crushing some grapes at the family winery, 1957. *Burbank Historical Society*.

Left: Bob Hope, the Duke of Toluca Lake, feigns interest while inspecting some obviously uninteresting film. *Burbank Historical Society*.

homes on the Verdugo hillside north of Glenoaks Boulevard, whose kids mainly went to Burbank High) or flatlander Burbankers (the working-class living on the valley floor in smaller homes whose kids mainly went to John Burroughs High). While there was a socioeconomic divide in town, we all knew that the future was bright in Burbank.

This is not to say that there weren't bad neighborhoods and even our very own skid row district in Boomer Burbank. In 1972, while driving around in town, Wes Clark's mother once sent him into the lobby of the Savoy Hotel on San Fernando Boulevard to look up some information in a telephone book. The Savoy was conveniently located next door to the Bottoms Up Bar ("pool-tap beer-cirrhosis"). Men, who appeared to have given up on life and the company of wholesome women, lounged in the lobby, reading the racing papers and sucking on cigarettes. A few of them wore battered fedoras (in 1972!) and sleeveless undershirts. It looked very much like a scene from a crime film from the 1950s, set in a squalid district of LA. And it didn't smell especially wonderful, either.

Another garden spot in Burbank was nearby: the Hotel for Men, which had a neon sign visible from Interstate 5. (It might just as well have announced, "Lower your expectations! We have bedbugs!") It was an easy target for *Rowan and Martin's Laugh-In* and received much notice during the run of that show.

BURBANK TODAY

The traditional socioeconomic divide (flatlanders and hillsiders) still exists in Burbank, but in general, the city has become less working class. And it almost goes without saying that the city fathers gleefully leveled the Savoy Hotel and the Hotel for Men as soon as they could.

For one thing, Burbank has become too expensive for your average waitress or factory worker to live there. For another, the Lockheed and associated company factories are all gone, replaced by retail and office environments for white-collar workers. That change started to take place in the eighties— along with the change from blue-white streetlights to yellowish sodium vapor lights, which changed the color palette of the city at night. (We never did accommodate ourselves to those yellow lights. Playing outside at night seemed much more mysterious and daring under those old blue-white streetlights.) The city now seems to be filled with media professionals and the hip. They are younger, trendier and better dressed. And they like to party at night.

Back when we were kids in the sixties, in the evening you could have fired an artillery piece down San Fernando Boulevard and not hit a thing—the shops all closed at five o'clock. But now there's a vibrant nightlife on San Fernando Boulevard, and the city actively encourages Burbankers to "Do the Boulevard"—the boulevard in this case being Magnolia, which seems to have become the epicenter for vintage clothing. Back in the sixties, there were antiques stores on Magnolia; one could spend an entire day rummaging through Avon bottles, Depression-era glassware and old signage. An antiques store constant back in those days seemed to be a poster-sized reproduction of a 1930s photograph of W.C. Fields holding a poker hand. Now the antique has made way for the chic.

But we are glad to report that some things have not changed. By and large, Burbank still seems the same: cozy little one-story homes in quiet residential areas with a table lamp casting a warm glow from corner windows—this seems to be a constant through the decades. Every now and then one drives by a home with a group of those funny little upside down V-shaped attic vents near the apex of the roof, or the holes which, as a kid, I thought signified an ornamental bird shelter of some kind.

But these quaint sights, while still common, are mixed with the sight of numerous large and rather unwelcoming apartment and condominium buildings, erected during the 1980s and 1990s on lots where traditional single-family homes once sat, blotting out the old feeling of neighborhood community.

Burbank. Burrrrrbank. The very name has connotations it never had when we Boomers were kids. *Rowan and Martin's Laugh-In* coined the enduring phrase "Beautiful Downtown Burbank" in 1968. (Nowadays, we call this sort of thing being snarky.) That, along with the frequent good-natured jibes by Johnny Carson during his post-1972 *Tonight Show* monologues, has established the name "Burbank" in the minds of people as a sort of synonym for a small community that has perhaps become, comically, too big for its britches, in much the same way as the word "Watergate" (referring to the Watergate Apartments in Washington, D.C.) has come to symbolize skullduggery and scandal. Evidence? How about the farcical low-budget movie *A Polish Vampire in Burbank* (1983)? A Polish vampire? That's reasonable. In *Burbank*? That's comedy. Or the even lower-budget *Bloodsucking Babes from Burbank* (2007)—along with the alliteration it must be noted that the inclusion of Burbank in the title gives things more a humorous impact than would, say, the use of Baltimore or Boston. There's a murder mystery by Michael Joens titled *An Animated Death in Burbank*—the reference here is not only a nodding

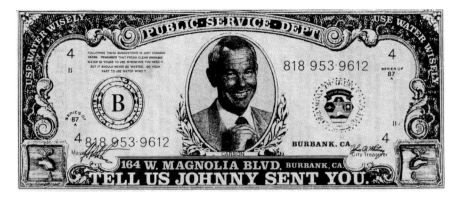

A little Johnny Carson promotional item sent with Burbankers' water and power bills. *Mike McDaniel.*

acquaintance with the humor of the city name but also a recognition of its status as a center for cartoon creation. And finally there's *Only the Dead Know Burbank* by Bradford Tatum, a novel about an undead German filmmaker who relocates to…well, you know where. The fact that our beloved city is in the title is a clear signal that this work is not to be taken too seriously.

It must be admitted that when we Boomers were growing up, Burbank was once a rather racially segmented place—and to some extent it still is. When the *Pulp Fiction* gunman, seeking a safe haven after accidentally blowing a man's head off in a car, said "I ain't got no other partners in 818" (referring to the mainly San Fernando Valley telephone area code), he was referring to the implicit hostility Valley types displayed toward ethnic Los Angelenos. But that, too, is changing.

Burbank has changed, but Burbank has also remained the same. (We will explore just how more fully in the last chapter for expatriate townies.) Ponder that as you stroll through the United States' largest IKEA store, newly built, which some Burbankers whimsically call "The IKEA that can been seen from space."

Finally, we can conclude that Burbank, like South Philly, Brooklyn or other select places in the United States, is the kind of place one never gets out of one's bloodstream, having been raised there. Burbanker Priscilla Griffin Shacklett said it best on Facebook: "No matter where you go or how long you live somewhere else, Burbank will always be home."

2
San Fernando Valley Suburbia

The nationwide notoriety of the San Fernando Valley began with a song that charted as a no. 1 hit in 1944: Bing Crosby's "San Fernando Valley." Like most of Der Bingle's music, it's quite tuneful and catchy, and if you go to the Disney California Adventure theme park, you can hear it played on the public address system. The song, invoking the "cow country" and mail delivered "care of R.F.D." describes what historian Michan Andrew Connor calls the Valley's "culturally imagined rural past" identity. The San Fernando Valley always pointedly seemed *not* urban.

The other end of the chronological musical bracket is Moon Unit Zappa's "Valley Girl," which was a Top 40 hit in 1982. (There was also a *Valley Girl* movie released in 1983.) The song features a long string of Valspeak (the San Fernando Valley dialect and jargon) about the shopping mall in Encino, fingernail grooming, clothing, offensive teachers, household chores, braces and the cat box. Growing up with girls who spoke an early form of Valspeak from the 1970s, it sounded like music to our ears. *Discordant* music, but music.

Here are some examples of the Valspeak we spoke during our childhood and teenage years. We are reasonably sure they heard these spoken prior to 1980. It is important to get the intonation right—drag out the syllables in a sort of crazy up and down cadence. If you are a Valspeaking female, be sure to often add a rising inflection to assertions, as if asking a question or begging for agreement. (There is a degree of a lack of confidence in being a teen, after all.)

BARF! BARF ME OUT!—So nauseating as to cause vomiting. Possibly an onomatopoeic word. Since "barf!" sounds a bit more Germanic, it's better suited to an explosive pronunciation.

BITCHIN'—Excellent. A surfer classic from the 1950s that remains in use in some quarters.

BOOK—To depart. "Let's book out of here."

BOSS—Good. Superlatively good. *Boss City* was the name of a KHJ TV dance show in the 1960s. Everyone knew that "BossAngeles" was boss. (Burbank, somewhat less so. No beaches.)

CHOICE—Excellent, but without the shock value of bitchin'.

DER-DE-DER!—How could you be so stupid?

DON'T HASSLE ME!—Hassle was an all-purpose word for an argument that could, with some encouragement, expand into physicality: "Ya wanna hassle?" "Are you *hassling* me?" It was usually uttered by aggressive teenage girls with ratted hair and blue eyeliner.

DON'T RANK ON ME!—Stop criticizing me. Or stop gossiping about me.

DUH—Again, how could you be so stupid? Somewhat less insulting than der-de-der because it has fewer syllables.

FER SURE!—An indication of confirmation. First heard circa 1978, fer sure.

GAG ME WITH A SPOON! (Also, **GAG ME!** Or simply **GAG!**)—How nauseating!

GO FOR IT!—A spoken encouragement, sometimes with mild sexual undertones.

GRODY—Another borrowing from surfers, not good. Nasty. **GRODY TO THE MAX** was as bad as it could get.

LIKE—A sentence starter and a sort of spoken comma. Example: "Like, wow, yes I want to go the Galleria, like, why not?" Sadly, it is still heard these days.

OH. MY. GOD.—Another sentence starter and a sure indication that one is being addressed by a future drama queen.

RIGHTEOUS—Excellent, but excellent in a mystical way. One young Burbanker used to say, "If I can dig it, it's righteous, and if it's righteous, I can dig it."

SHINE IT ON—Fuhgeddaboudit. Alternatively, to be disingenuous or false. "He was just shining me on" might be something a Burroughs High girl would say about a Burbank High guy who just wanted to make out but was pretending that he was more serious. (One of many Bulldog stratagems.)

TOTALLY!—A stronger expression of (total) confirmation or agreement.

TWITCHIN'—The same as bitchin', but more polite for use in elementary schools.

ULTIMATELY—Perhaps the strongest expression of endorsement. Example phrase: "Those shoes are ultimately cool."

Baby Boomer San Fernando Valley residents have seen their expenses (and home values) shoot up over the decades to the point where living in the valley has become a costly proposition. But when we were kids, the cost of living—which we were insulated from, those being parental concerns—was mollified to a certain extent by a kind of Burbanker superiority, even snobbery. We knew Burbank was better than, say, North Hollywood. You could tell that simply by driving down the roads. In Burbank the roads were smoother and better maintained. (North Hollywood has since morphed into the trendier NoHo, and things have changed. Somewhat.) And Sun Valley? Forget it. That's where you found the automotive junk yards. And while Los Angeles was the big city, bold and internationally famed for being the home of glamor, traffic was a pain. San Fernando Valley residents have always felt a sort of disconnectedness with LA, hence the various Valley secession movements through the years beginning in 1977.

The Boomer Burbanker's relationship with the greater San Fernando Valley varied from person to person, but, in general, back in the 1960s and 1970s, we saw retail, entertainment and dining variety in the following places:

ALEX THEATER—On Brand Boulevard in Glendale, a place to see movies not playing at the California, the Cornell or the Magnolia in Burbank. The authors saw *Blazing Saddles* (1974) and *Monty Python and the Holy Grail* (1975) there—arguably, two of the all-time greatest achievements in the history of Western cinema.

BRAND LIBRARY—Part of the Glendale library system, it was one of the few true cultural centers of the Valley: a magnificent collection of art books and music (vinyl records, cassettes and sheet music) located in a wonderfully eccentric early twentieth-century grand home built to invoke the mystical east. Slumming here was, say, using one of the turntables to listen to one of their recordings of Beethoven's Fifth Symphony rather than a recording of Karl-Birger Blomdahl's obscure *Aniara—A Space Opera in Two Acts*. (They had both.) The grounds were beautiful, too, and behind the library was a trail that led up to the peaks of the Verdugo Hills. And a family cemetery. With a climbable pyramid. Kids from the local neighborhoods enjoyed walking up here, with helmets and plastic tommy guns, to play war. The hill trails, with overgrown plants and bamboo, made for convincing Pacific war scenarios.

BUSCH GARDENS (VAN NUYS)—Where Vals saw birds and flora and got Anheuser-Busch beer. You could take a little monorail that showed the fascinating steps necessary for brewing beer in the factory. Johnny Carson

once claimed that the beer vats were cleaned out by lowering Ed McMahon on a chain and having him lick the sides of the vats clean. The story is that when this place shut down in 1979 they released the parrots, who flew away, bred and noisily swarm into Burbank from time to time to bespatter homes and cars. That's one account, anyway.

CRUISING VAN NUYS BOULEVARD—Driving up and down Van Nuys Boulevard, wasting gas, peeling out, gaping at girls, being young. It was so celebrated an occupation that a low-budget exploitation film was made about it in 1979, titled, fittingly, *Van Nuys Blvd*. Think *American Graffiti* but set in the Valley and with a lot less artistry and plot.

FARRELL'S ICE CREAM (VAN NUYS)—Wow, what a noisy, chaotic and fun place this was! Bells, sirens, the teenage wait staff yelling and making announcements and so on. A fourteen-year-old Wes Clark once ate an entire "Pig's Trough" (*two* banana splits)—it was no sweat—and received his due attention on the floor of the restaurant. One of the things that made this place so exciting was the typical Los Angeles teenager who served as waiters and waitresses. Naturally "on," extroverted, loud and show bizzy, LA kids are unlike kids anywhere else in the United States.

El Miradero—Brand Library—Glendale's premier arts library. *Mike McDaniel.*

GLENDALE GALLERIA—Along with Topanga Plaza, it was *the* place to go after 1976, when it opened for business. The exterior of the dark, windowless place resembled a fortress.

HANSEN DAM—A dividing line between Baby Boomer cohorts is evident based on whether or not one's family enjoyed recreational activities here. When the authors were growing up, this site, situated near Pacoima, was considered unsafe and a high-crime area. But people who had fond memories of the place in the decade or two after it was built in 1940 remember it very differently.

THE HOLLANDER—A Dutch-themed cafeteria in Glendale. The main room featured a giant tiled mosaic of an ice-skating Dutch boy and girl. The food may have been typical cafeteria fare, but the place was always crowded.

LEON'S STEAK HOUSE—North Hollywood's best steak house. (Is that really saying something?) One especially prized an older waitress who, if a customer ordered something that was getting complaints or otherwise didn't meet with her approval, silently shook her head "No." Then the customer could try again with something else. This was a rather up-market restaurant in the Valley—or it seemed so when we were kids.

MUNTZ STEREO (VAN NUYS)—A small, crowded business that specialized in installing 4-track (Muntz invented the format), then 8-track, then cassette stereo systems in cars. Madman Muntz, dressed like Napoleon, claimed, "I wanna give 'em away, but Mrs. Muntz won't let me!"

SEARS AT VALLEY PLAZA—Before there was Wal-Mart or Sam's Club, there was Sears, America's department store. The thing to do here was to examine harvest gold trash compactors and polyester clothing while munching candied nuts from the little counter in the center of the floor space.

SUN VALLEY JUNKYARDS—This is where we went to get parts for repairing our used cars. Pick Your Part had the best selection for the cars we cruised in. Its sign featured a very amateurish painting of an octopus holding auto parts in its tentacles. An octopus. Of course. Sun Valley being so maritime and all.

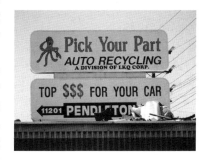

Sun Valley's Pick Your Part, a Valley gathering spot for backyard mechanics. *Mike McDaniel.*

TOPANGA PLAZA—All the way down the 101 to the western part of the valley in Canoga Park, but the drive was worth it. In the late 1960s and early 1970s, it was a riot of orange and gold

A postcard image of the Topanga Plaza, circa 1969. *Courtesy of sanfernandovalleyblog.blogspot.com.*

and featured an ice skating rink, a Wallach's Music City record store and, in the grand foyer, three-story strands of what looked like monofilament fish line that had constant drops of mineral oil flowing down them to a plastic garden with Astroturf. Called the "Rain Forest," it was a mesmerizing thing to behold. So Valley!

Finally, for what it's worth, we conclude this chapter with excerpts from a long list authored by anonymous Val Boomers of various ages titled "You're Seriously Old San Fernando Valley If You...":

> *Visited the Old Trappers Museum; Had a beer at the Cactus, the Web or the Ramp; Ate burgers at Times, Crazy's, Bob's, the Sirloin Burger or the Dip; Swam at Sun Valley Park, Pops Willow Lake, Fernangeles Park, Pickwick or McCambridge Park; Bought Christmas presents at the Akron, White Front, Fedco, Zodys, Gemco, Sav-On or Unimart; Bought your Levis and Sir Guys at Sun Valley Men and Boys or Peoples Store in San Fernando; Went water skiing or boating on Hansen Dam when they allowed power boats; Thought the only Valley was the San Fernando Valley; Ate a hot dog at Hugo's or Cupids; Thought the only canyon was La Tuna Canyon; Heard the air raid sirens at 10:00 a.m. on the last*

Friday of the month; Saw a boxing match or roller derby at the Valley Gardens; Bought milk at the Altadena Dairy, Van Nuys Quality Dairy, Manfull Dairy or the Roger Jessup Dairy when they had cows at the dairies; Bought stuff at Whalen's Drug on Vineland and San Fernando; Roller skated at Melody Land, Rainbow Roller Rink or the Rollercade on Lankershim and Hart; Ice skated at Schramms or the Ice Capades Chalet at Topanga Plaza; Remember when the Seaside changed into a tire shop with a gorilla out front; Remember when the mid-air crash rained flaming debris on the boy's athletic field of Pacoima Junior High; Ate Chinese food at Phil Ahn's Moongate; Remember when the "partial" nuclear meltdown in experimental reactor in Chatsworth in 1959 affected everyone west of Coldwater Canyon; Had a 76x-xxxx (ROscoe x-xxx) or 24x-xxx (CHase x-xxx) telephone number; Ever had to ask Louis Forsch to help you find anything at Roscoe Hardware; Were around when Roscoe became Sun Valley; Attended Glenwood, Fernangeles, Canterbury, Roscoe, Stonehurst or Vinedale Elementary Schools; Were in an "A" or "B" grade at Sun

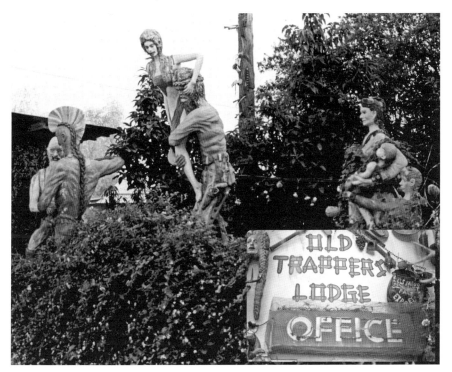

The Old Trappers Lodge. Sort of creepy, like the Bates Motel. Did anyone ever spend a night here? *Mike McDaniel.*

Valley, Madison or Byrd Junior High…before they became middle schools; Consider when matriculating K-12, fall was "B" session and "A" was spring session; Bought doughnuts off the Helms truck; Experienced fine dining/ever dined at Van DeKamp's, Leon's, the Red Barn, Hody's, Sargent's, Rusty's, Otto's Pink Pig, the Pink Café, the Long Green Café, Moskva Cliff Restaurant, Chris and Pitts, Tail o' the Cock or the Smoke House; Got your news from the Valley Times or the Valley Green Sheet; Bought crap at the Twin Cannon Trading Post or Palley's; Looked at but never bought a rhinestone shirt at Nudie's on Lankershim; Took a date to the Cornell, Magnolia, Burbank, Loma, La Reina, Panorama, Lankershim or the El Portal; Rode your bike everywhere before mothers became the mode of transportation for kids; Went to the San Fernando Valley Fair at Devonshire Downs; Used clothes pins and playing cards on the spokes to make your Schwinn bike ride really cool; Knew where Basillone Homes, Orcas and Rodger Young Village were…but never went there; Went to the "new" mall, the Valley Plaza, on Laurel Canyon; Remember the gravel pit on Vineland that became Gemco and then became a pit again when it sank; Watched the submarine races at Stough Park, Hansen Dam, the top of the canyon or Glen Haven Cemetery; Bowled at the Mar-lin-do,

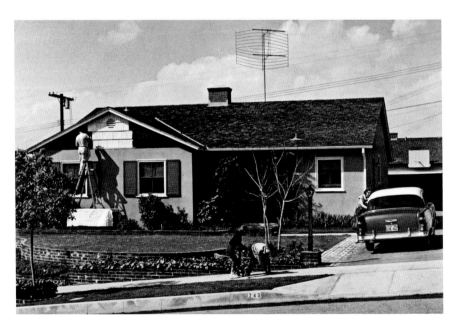

The 1950s were like this: typical Valley folks at a typical Valley home (in Burbank) with a typical American car. *Burbank Historical Society*.

*Matador, Starlight, Ronell or Sun Valley bowling alleys; Were ever in the Palomino Club; Waited for the train to cross on Vineland, Hollywood Way or Tuxford; Went to see Santa and his reindeer in Panorama City; Saw "C/S" (*Con Safos Por Vida*) in every men's room in the Valley and wondered what it meant; Took trash to the Tuxford or Branford dump; Remember when gangster Mickey Cohen witnessed somebody putting a bullet between the eyes of Jack (the Enforcer) Whalen on Ventura Boulevard in Sherman Oaks.*

That last one is scary. Well? How many did *you* do?

3
SoCal Sojourns

Growing up, we Southern Californians knew the place was kind of odd. There was no avoiding it. We'd hear it from out-of-staters: "California is the land of fruits and nuts. If you're not one, you're the other!" *Har-de-har-har*. And whenever Wes Clark was forced to divulge his hometown to a Marine, he braced himself for the inevitable slights. (It was especially vitriolic coming from drill instructors in boot camp. After graduation, we were mockingly known as "Hollywood Marines" because, as westerners, we went to boot camp in San Diego. We didn't get to enjoy recruit training in Parris Island, South Carolina—where humidity and sand fleas held sway.)

The situation, in the twenty-first century, is now worse than ever. Southern California is the (Loony) Left Coast, presided over by "Governor Moonbeam" (Jerry Brown). But back in the 1960s and 1970s, it couldn't be hidden that the sense of dislike and resentment for California from people living in other states was mixed with a pronounced envy. After all, in 1962, the state surpassed New York as the state with the largest population. We had the weather, the movie stars, the beaches and the much-talked about California lifestyle, and green-eyed new residents were flocking over to have them as well. Visitors saw proof of our being the Golden State simply by watching the sun set over the Pacific Ocean. In the 1972 election, California's electoral vote count, based on the 1970 census, surpassed New York's for the first time ever—it was a matter of pride that we were now politically important.

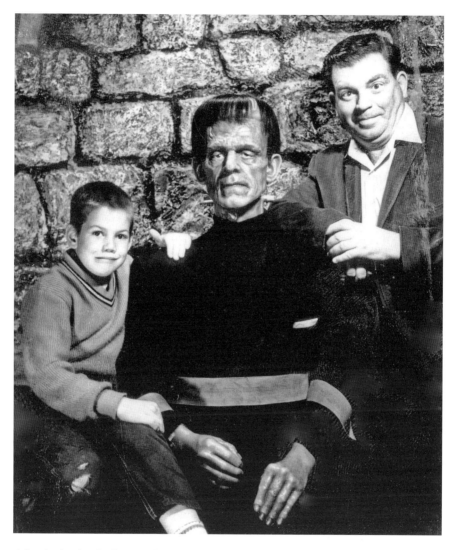

A fun destination for Boomer Burbankers was the Movieland Wax Museum in Buena Park. Since it's 1964 and monsters are a fad, Frankenstein's creature was set up as a photo-op for Wes Clark Jr. and Sr. They look suitably unnerved. *Wes Clark*.

For Burbank Baby Boomers, Southern California was a sort of extended backyard. The pervasive automobile culture had us all out on the freeways exiting the Valley, and the region's theme parks—Disneyland, Knott's Berry Farm, Sea World and Pacific Ocean Park—were considered a sort of birthright. They just kind of came with the place. We Burbankers even had special access to Disneyland, "The Happiest Place on Earth!," as there

was an annual "Burbank Nite" held there. (Note: Disneyland also had high school Grad Nites, Marine Corps Nites and Mormon Nites. Curiously, the time most likely to get a sticky candy dropped on one's head from somebody riding the Skyway buckets was during Mormon Nite.)

Expatriate Californians with a theme park–heavy upbringing, living among historic areas in the East, have a special view of things. The programming that the Knott family and the Disney organization instilled in Californians resonates to the present day. For instance, one might visit historic and picturesque Harpers Ferry, West Virginia, a place characterized by stunning mountains and the confluence of the Potomac River and the Shenandoah River. But it's easy to walk down Shenandoah Street and see the carefully maintained nineteenth-century storefronts and think, "Hmmm. It looks like Frontierland at Disneyland!" One might think the same thing during a visit to Fort McHenry in Baltimore. It's actually the other way around: the look Disney intended for Frontierland is based on the actual

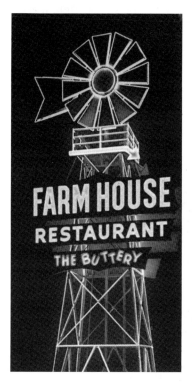

Arnolds' Farm House giant neon windmill, an unmistakable landmark alongside I-5. *Wes Clark.*

historic sites and the replica should not be allowed to diminish the real. And so it goes…Independence Hall in Philadelphia draws inevitable comparisons to the reproduction building at Knott's Berry Farm or even Bellarmine-Jefferson High School on Olive Avenue. Seeing the real Old North Church in Boston can remind a Californian of the reproduction at Forest Lawn. The Tower of London will inevitably remind one of seeing the castle set for the movie musical *Camelot* (1967) on a Warner Bros. backlot tour. Spandau Castle in Berlin, Germany, seems like the Universal Studios stone tower constructed for the Charlton Heston movie *The War Lord* (1965). A Virginia plantation on the James River might remind a Burbanker of a big home above Glenoaks Boulevard. And every old-timey windmill seen against the sky draws (poor) comparison with the sixty-foot, neon-lit one that used to be a Buena Park landmark along I-5 for the Farm House restaurant. And even if you

have never laid eyes on a real western ghost town, the authors know what you'll think when you finally see one: "It looks like Knott's." It's insidious! But such is a California upbringing.

Few Burbankers are aware of this, but, initially, Walt Disney once considered the area of his campus along Buena Vista Street in Burbank for a visitor's park, his "Disneyland." He got the idea for a park partially because people were requesting tours of his studios. However, as his plans matured, it became obvious that more land was needed, so the project moved to Anaheim.

Another artifact of a Southern Californian upbringing is a perpetual inability to dress for the weather in other states. Weather forecasting, while an inexact science, is much better developed and more accurate than it was when we were kids thanks to the processing power of modern computers as well as a better knowledge of weather lore. (El Niño or La Niña climate patterns were unknown to us when we were young. If asked what these were as kids, we probably would have lamely mentioned something about Columbus' ships.) Nowadays, in many places in the United States, forecasters can make reasonable hour-to-hour assessments of the likelihood of rain or an approaching cold front. But Californians, used to boring but comfortable weather, have apparently ignored all that and stand, freezing, in a light jacket when a wool coat would have been a far better choice. And it's amusing to view old photographs of Disneyland attendees: the men are in suits and the women are in dresses and nice shoes. People dressed far more formally in the early Boomer era than they do nowadays, when a T-shirt with a vulgar slogan is considered perfectly acceptable theme park wear.

The Happiest Place on Earth. Especially after finishing high school! *Mike McDaniel.*

37

Some of our Southern California hangouts during the Baby Boomer era:

CLIFTON'S CAFETERIA—A legendary Depression-era cafeteria on Broadway in downtown Los Angeles, the motto here was "Pay what you wish"—a boon to the unemployed. At least it was during the Depression; people in the 1960s and 1970s simply paid what was posted. It's likely that many birthdays were celebrated here. The interior was designed to look like a redwoods forest at night; best of all was a little stone chapel on the second floor where one could enter and view a diorama of a forest. When a button was pushed, a spoken voice intoned a poem about the redwood tree. The place was remodeled in 2012, and the neon cross was removed from atop the chapel, making it presumably nondenominational.

DEL MAR RACETRACK—"Where the turf meets the surf down at old Del Mar/take a train, take a plane, take a car!" as Bing Crosby would sing before post time. Del Mar was a delightful little beach town. It wasn't quite the destination for Lockheed workers that Las Vegas was because there was no opportunity to throw away money twenty-four hours a day. Wes Clark Sr. loved the Daily Double, but Wes Jr. usually played it safe by betting the favorites for Show. He rarely tore up a ticket, which caused his Brooklyn father to remark about his penny-pinching ways: "You're tighter than a frog's ass stretched over a rain barrel!" During a 1967 trip, Wes's mother got so excited when her horse came in that, shouting exultantly, she dropped her dentures onto the level below the deck she was standing on. Shouted requests by Wes Sr. and Wes Jr. to bystanders to pick the dentures off the ground before someone trod on them went unheeded.

In Burbank one didn't have to drive to the track to play the ponies. In the 1960s, one famous Burbank eatery—still in business and therefore remaining unnamed—had a thriving Saturday morning kitchen operation. Money was collected, and runners took the bets to the track on behalf of the others. Later, the winners (with actual names like Mugs, Clancy and Mac) would be paid off. It was the in-group to know if one liked horse racing.

DISNEYLAND—The granddaddy of the theme parks, and, for many Boomers, still the best. A smiling cast member or a photo-op wherever you look, and nobody manages crowds with the same experience and aplomb as Disney. Everybody knows about Werner Weiss's *Yesterland* website at yesterland.com, right? This is *the* place to go for Baby Boomer memories about Disneyland. Here's one: In August 1969, Wes Clark's mother took him to see the newly opened Haunted Mansion attraction, a week or two after it launched. He was blown away. To commemorate the occasion, at the ride exit under a

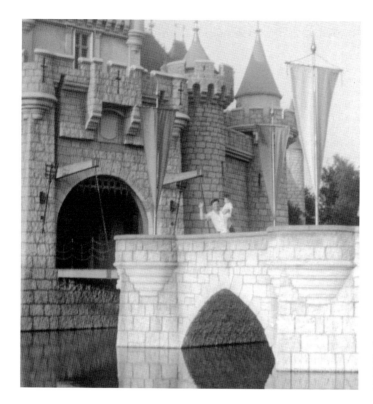

Wes Clark Sr. and Jr. at Disneyland, 1957. *Wes Clark.*

metal railing atop a stone wall, he surreptitiously placed a Dyno label that read, "Wes Clark was here." It was hidden; you had to know where it was and bend over to find it. At subsequent trips to the park, he'd check to see if the label remained. It did, painted over but still intact, for years. (It was still there during a 1982 visit.) Prior to 1989, when Splash Mountain was being erected, the railing was torn down— presumably with the label intact, cemented into place via multiple enamel paintings.

GRIFFITH PARK OBSERVATORY—In addition to the usual scientific displays, in the early 1970s, a new attraction was opened that garnered big crowds: the Laserium. Essentially a laser light show set to music (was Emerson, Lake and Palmer's "Abaddon's Bolero" one of the tunes?), Dan Sullivan, in a September 25, 1974 *Los Angeles Times* article, wasn't terribly impressed: "As the show goes on the darkness reminds one less of deep space than of a blackboard for a dazzling but not deeply absorbing display of self-automated geometry, a huge step beyond Dancing Waters but of the same nature....Laserium got the ultimate accolade of the young people in my row ('All right!') and it is more for them just now than for anybody."

WANTED!
DEAD OR ALIVE
$5,000 REWARD
HORSE THIEF
MOUSE EAR-MIKE, WILD RED,
HOOKNOSE BLACKIE, TULSA TOM
BOGUS JOE AND A FEW OTHERS.
Signed *Rex J. Sands* Ghost Town Sheriff
may 5 th. 1858

At Knott's Berry Farm Ghost Town, everyone can be a horse thief, including a teenaged Mike McDaniel, 1973. *Mike McDaniel.*

KNOTT'S BERRY FARM—The really good rides, the roller coasters, started to appear in the late 1960s. Prior to that, this park was heavily educational, as if the Knott family were history teachers working your family on the weekends. The models of the various California mission buildings were pretty underwhelming for kids, but one could pan for gold and watch a desperado gunfight here. The 1969 opening of the Calico Log Ride was a big deal. Mike McDaniel and his father were at the opening of the attraction and saw John Wayne take the first ride; it was memorable to be in the presence of the Duke. The log ride is still Mike's favorite at the park today. The Mystery Shack (a house featuring uncanny optical illusions) made a big impression until it was demolished in 2000. So did the gift shop, where the house lights would periodically dim to allow black lights to make all the phosphorescent goods glow eerily—a major selling point for a little boy. The barn at Knott's now called the Wilderness Dance Hall used to be the James J. Jeffries barn on the corner of Buena Vista Street and Victory Boulevard; boxing matches were held there for many years.

LAS VEGAS, NEVADA—It may be known as the western gambling capital of the United States, but it was actually an annex of the Lockheed Aircraft Company. At least, based on all the discussion about weekends spent there by employees in the plant (some of whom called Las Vegas Lockheed East), it certainly seemed that way. When Elvis sang about blackjack, poker, roulette wheels and a fortune won and lost on every deal in "Viva Las Vegas," he could just as well have mentioned Burbank machinists crapping out and making the long drive back to the San Fernando Valley dead broke.

NEWHALL AND SAUGUS SWAP MEETS—The 1970s swap meet craze, later perfected at the Rose Bowl, began in this pleasantly rural part of Southern California. The usual items seen at these were macramé hanging planters, Marks-A-Lot markers, colorful assortments of Hemingray power line insulators and a poster of Wile E. Coyote holding the Roadrunner by the neck saying, "Beep Beep Yerass."

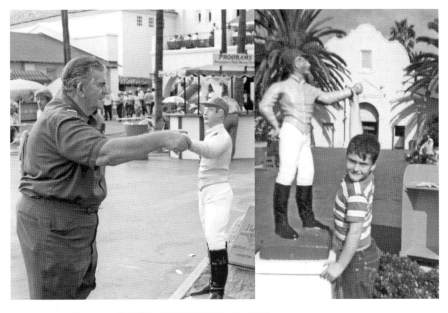

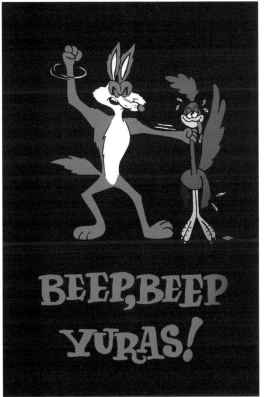

Above: Del Mar Racetrack. Wes Clark Sr. and a young Mike McDaniel shake hands with the same jockey many years apart. *Wes Clark and Mike McDaniel.*

Left: A rude poster seen at every swap meet in California circa 1969. (This one is for black light.) A young Wes Clark didn't get the joke and thought *yuras* was some Spanish word. *Wes Clark.*

Left: A four-year-old Wes Clark inspects some elves at Santa's Village near Lake Arrowhead. *Wes Clark*.

Below: California beaches—there are none better, except possibly in Hawaii. Toddler Wes Clark takes a swig from Dad's beer, June 1957. *Wes Clark*.

SANTA'S VILLAGE—A Christmas-themed park near Lake Arrowhead that opened in 1955. Strictly a place for parents of young children to go to take seasonal photographs of the kiddies, the rides were underwhelming (especially compared to Disneyland, which opened about the same time).

SOUTHERN CALIFORNIA BEACHES IN GENERAL—Burbank had a large and vibrant surfer community, and many high school kids surfed nearly every single day. They could be identified by their white-blond hair that almost seemed oiled into place. Sometimes surfer hair resembled shiny oak wood. Every SoCal kid has beach memories.

UNIVERSAL CITY STUDIOS—Visitors rode through the studio lot via "Glamour Trams." It must be admitted that the parting of the Red Sea (from *The Ten Commandments*) effect was pretty lame and low tech. However, Universal more than made up for that with one of the greatest-ever effects built: running the tram through a rotating tunnel that simulated icy surfaces. Motion being relative, it looked very much like the tram itself was spinning on an axis in the direction of travel—it was simple, but memorable and effective. Girls screamed their heads off. In the summer of 1970, an International Festival was held at the International Village (sort of a forerunner of EPCOT's "World Showcase"); a big attraction for teenaged boys were the girls in peasant blouses. After 1976, the vicious little kitchen knife–wielding Zuni fetish doll from *Trilogy of Terror* (1975) could be seen in a darkened hall on display under a glass dome. Did it just twitch ever so slightly? (It did.)

Let's Go to Standard Brands!

With the increased amount of leisure time Americans enjoyed in the 1960s and 1970s came an increased demand for creative outlets. The traditional way this was filled was with sewing, quilting, woodworking and painting (paint-by-number finished products blighted many an American interior in the 1950s), among other occupations. The Baby Boomer era, however, introduced entirely new craft fads and encouraged unrestrained creativity among the working and middle class. The seventies seemed especially ripe for a crafts explosion as the do-it-yourself movement collided with the general questioning of anything that represented musty old notions about décor or less penetrating and ecstatic modes of living:

> *Why not use that wooden industrial cable reel as a coffee table?*
> *Why not employ that rusty, discarded sign as a wall hanging?*
> *Why not re-purpose that milk can as a seat?*
> *Why not arrange a grouping of glass power line insulators as table top decoration?*
> *Why not adapt those milk crates into bookshelves?*
> *Why not recycle that yard sale bowling alley bench as patio furniture?*
> *Why not distort that 7-Up bottle with an oxy-acetylene torch to form a fascinating sculpture for décor?*
> *Why not manufacture an amusing brooch, necklace or bracelet out of beads threaded onto safety pins?*

Why not fill an old printer's type drawer with tiny pieces of junk and hang it on the wall?
Why not create an attractive vest or hat out of aluminum beer can pop tops?

Why not? It's not like good taste was going to be allowed to get in the way during the seventies.

Wes Clark's mother, Madeleine, a waitress at the Copper Penny on Olive Avenue near the NBC Studios and, later, Sargent's Restaurant on Victory Boulevard, was an avid crafter. Some of her endeavors undoubtedly reflect other Burbankers' creative activities, but others were her own unique realizations of suggestive whispers from a mischievous muse.

For instance, in December 1962, when the family lived in the Silver Lake district of Los Angeles, Mrs. Clark wondered, "Why buy a Christmas tree? I'll just make one. Out of rebar." So she fashioned a series of U-shaped steel rebar rods, hung them together concentrically on an axis, and then encircled the structure with loops of rebar. The rebar was held together by wire, and the whole thing wound up looking like a bird cage (for an especially mighty bird). Mrs. Clark then affixed Christmas tree lights at each point where the horizontal and vertical rebar met, and she hung the ornaments in the square

Madeleine Clark hard at work on another craft project, 1976. *Wes Clark.*

spaces formed by the rebar. The whole thing was then wrapped with "angel hair," a gauzy white spun glass substance popular in the 1960s that was wicked to the touch. "Unique" didn't begin to describe the Clark family Christmas tree that year. It was suspended by a hook from the ceiling in the corner of the living room; the hook was presumably in a sturdy joist. Since the room had corner windows, the space age masterpiece could be viewed by passersby on the street. Somehow a photo was never taken, which is a matter of enduring regret.

(After the season was over, Mrs. Clark discarded the Jetsons tree in the back yard, where it served Wes as a play spaceship. He vividly remembers how sharp the edges of the cut rebar were—it was a spacecraft one entered with extreme care. And getting the angel hair off of it was a nasty proposition, too. His hands were full of microscopic slivers.)

A focal point for crafts in Burbank was the Standard Brands store on Victory Boulevard at Cypress Avenue. One could buy essential crafting items here: resin, luan, gold-veined mirror tiles, Mod Podge for decoupage work, carpet tiles and glitter.

Mrs. Clark discovered the craft resin fad in 1969, and from then on, Standard Brands became her source for resin, hardening catalyst and resin colorant as well as the necessary cigarette lighter, ashtray, clock case, swag lamp and soap dish molds. (Mrs. Clark held the line at resin toilet seats. Too Las Vegas.) The fact that nobody in the Clark family smoked was of no concern; homemade resin ashtrays were seen strewn about for guests in the living room, patio and den. This was, after all, in the days before concerns about secondhand smoke, and Mrs. Clark wanted to be a good hostess.

Ashtrays and other resin items were made Burbankian by the inclusion of L-1011 TriStar rivets and other small aircraft parts donated by Lockheed factory workers. Mrs. Clark found enthusiastic recipients among these folks and frequently described how so-and-so wanted a blue soap dish with an L-1011 lapel pin and a rivet or two inserted therein. Or some assembly line supervisor wanted a matching red lighter and ashtray set with the Lockheed logo for his living room with the Spanish interior and red carpet. (Remarkably, Lockheed items in resin can sometimes be found on eBay.) Curiously, Mrs. Clark never attempted one of the ubiquitous sets of resin grapes seen in 1970s interiors, usually placed atop the console stereo.

Wes Clark got a hand in the family craft as well and manufactured a pair of swag lamps for his bedroom. This involved pouring the resin into small rectangular molds, coloring each one differently. They were cemented into place in metal swag lamp frames purchased...where else? These were

The Clark family's ship's hatch coffee table, shown here with a bunch of stuff stuck to it, including the teapot. April 1970. *Wes Clark.*

then hung from the ceiling with chains; a light bulb was set in the center of the lamp with the lamp cord threaded through the chain. It was especially impressive to turn off the other lights in the room, then to give both swag lamps a good spin, sending colors whizzing by on the bedroom walls. Quite psychedelic, as people used to say in those days.

Mrs. Clark's major project with craft resin was embellishing the family ship's hatch coffee table, but this turned out badly. Since there didn't seem to be a good way of totally encasing a large wooden ship's hatch into a solid block of resin plastic like the professionals did (Standard Brands didn't sell a mold for that), she had to be content with merely pouring the resin over the table to coat the surface. She rounded up some especially attractive stamps from her collection and commemorative medals of the presidents (gas stations gave these away as promotional items) and poured away. After several layers, the top was smooth and shiny, but the sides had solidified drips; Wes used to enjoy snapping these off.

The table's undoing was with the thermal properties of the craft resin. When the stuff finally dried (after a fashion, it never seemed to have completely set) to an initial glassy shine, Mrs. Clark moved her new showpiece into the family room with the television and fireplace. But the Clarks soon discovered

that anything hot placed on the table, like a pot of tea, would stick firmly to the resin. Mr. Clark tried to circumvent this problem by setting his teapot on a piece of newspaper, but the newspaper stuck as well. A resin-covered ship's hatch table with bothersome scraps of old newspapers had no place in the Clark family's overall decorating scheme, so it was eventually moved into the backyard to die from exposure to the elements.

Another valued Standard Brands product was luan, a thin wood product manufactured in some banana republic. Where other people would use respectable plywood (interior or exterior, as needed) for household use, the Clarks used luan. A wood's a wood, isn't it? Wes Clark's father once nailed sheets of the stuff onto the backyard fence in an attempt to dress things up. It was an ill-advised procedure, since luan was certainly not an exterior use product. Sun and rain soon warped and rotted the luan. Wes found interest in breaking up, burning and hurling luan fragments around in the backyard—there was a certain tactile gratification in flinging it like a Frisbee and watching it fly apart when it struck something. But he soon learned that broken luan is almost as hellish as angel hair: it had sharp, needle-like pointy edges. Wes was forever pulling luan slivers out of his hands during his childhood.

Wes Clark Sr. was also an interior luan craftsman. In 1966, he decided that the living room cabinet was too boring, so he painted it using an antique avocado staining kit and some gold and scarlet paint, and affixed some bits of decorative luan from a sheet (not caring about the two pieces being symmetrical). The end result was Clark's Box of Mystic Secrets from the Hidden Orient. Or, a piece of crap in Burbank. Mrs. Clark was not pleased, so the piece only graced her living room for a year or so before she got rid of it.

A problem with crafts or, depending upon your view of crafts, an advantage, is that when one makes crafty items one must, (1) Fill up the house with them, (2) Sell them or (3) Give them away to friends. So there was indeed the ubiquitous Barbie-like doll standing within a roll of toilet paper, her long crocheted dress draped over the roll, placed on the tank of the family toilet. The toilet paper doll was dressed as a Spanish lady and was given to Mrs. Clark by an elderly friend.

Did the Clark family also have gold-veined mirror tiles in the house in addition to the spare toilet roll lady? Check. Mrs. Clark was susceptible to that 1960s and '70s interior design fad as well. She put them up, figuring that they would make the room seem bigger, which was certainly the case. Taking them down was a lot more fun than putting them up because a hammer was involved.

Left: Wes Clark Sr.'s exotic cabinet, trimmed with luan, 1967. *Wes Clark*.

Right: Did the Clark family have a room with fashionable 1960s gold-veined mirror tiles? Affirmative. *Wes Clark*.

And how about macramé? Could that be found in the Clark home? Yes, in abundance starting in 1975. Mrs. Clark's hanging plant collection got very large; in the photo, we see only a small fraction of the total number of plants that were in the patio. (One white pot had a "Proud Mother of a United States Marine" sticker on it.) Hanging plants, however, were something of a high-maintenance item, and since Mrs. Clark was busy running the family business, their days were numbered. With neglect, most of them died off. The macramé hangers and the pots weren't removed, though, so for a long time the Clarks had a big collection of dead house plants. Wes called it "the Addams Family greenhouse."

Then there was the aluminum pop top craze, where hats, vests, bracelets, necklaces and handbags were manufactured out of the discarded pull tabs. (Later on in the seventies, manufacturers learned how to make the can-opening tab remain attached to the can.) One family on Lincoln Street, who had parties often, had soda and beer can pop tops to spare and so the mom produced wearable aluminum goods.

For a time, Mrs. Clark, being a constant and enthusiastic promoter of the Lockheed L-1011 TriStar passenger aircraft, took to building L-1011 model airplanes, which she'd cut in half and affix onto a rectangle of framed sky blue felt. The different paint schemes of L-1011 aircraft—British Airways, TWA, Delta, Pan-Am, Air Canada and so on—were represented in their

Wes and Madeleine Clark pose with some plants hanging in macramé holders. *Wes Clark*.

own frames. What did she use to represent billowy clouds? Angel hair, of course. These were hung up in the Alibi, the café she managed outside of Lockheed on Empire Avenue. This boosterism wasn't a hit with all. One customer shared his displeasure: "We have to look at those things all day and can't even get away from them when we come in for lunch!"

There was also the safety pin beaded jewelry fad, another one of Mrs. Clark's interests in the early 1970s. These could be quite elaborate. She once made a rather colossal brooch that Wes took to school, claiming that he had made it, to fulfill a disliked requirement in an art class. What was embarrassing was when an attractive girl in the class, seeing it, expressed fascination and started asking detailed questions about its manufacture, how he got into the hobby, where he bought supplies and so on. Wes tried to be

L-1011 TriStars flying in billowing clouds of angel hair, 1974. *Wes Clark.*

glib and inventive, but it became pretty obvious that the girl wasn't buying what he was selling.

The main craft for the authors was the very same thing that the great majority of American boys were involved in: building model airplanes. Wes Clark had a World War II air force of his own suspended from his bedroom ceiling. (He got the idea from visiting a Burbank hobby shop that had a simply incredible collection of planes displayed this way.) He was a big fan of any bomber aircraft that had ball turrets; those were fun to build and rotate when completed. They looked impressive, too, especially when he was able to keep the airplane glue from getting onto the clear window parts and fogging them up. Wes Clark's model airplanes had two phases of existence: The first was after being built, suspended from the ceiling. The second was

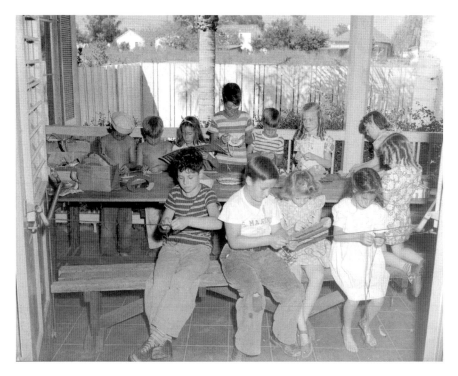

Burbank kids making boondoggles (gimp) and other crafts, Olive Rec Center, 1950s. *Burbank Historical Society.*

after he tired of a particular plane, which was taken down and brought to the backyard. A bit of gasoline and a match simulated an especially fiery mishap or battle damage. Then the plane was buried. Future archaeologists performing a dig at 1631 North Lincoln Street may wonder at all the melted plastic buried in the backyard.

Shopping in Burbank

Back in the 1960s, it must be admitted, Burbank had an intangible retail inferiority complex compared to other jurisdictions, especially Glendale, the adjacent city to the east. While Burbankers indeed shopped in various places in town, it was generally agreed that the Valley Plaza (where the big Sears was) or the Glendale Galleria offered the premium shopping experiences. But for some, downtown Burbank was perfectly adequate. When the Clark family first moved into their Burbank home, they shared a back fence with an old man and his wife. The aged gent occasionally mentioned that he was headed "downtown" that day. The Clarks used to wonder if he meant Los Angeles or downtown Burbank. The mystery was solved when the Clarks once discovered him outside the San Fernando Boulevard Sav-On drugstore, sitting on a bench, contentedly licking an ice cream cone.

What follows are notes regarding some of Burbank's popular retail destinations. Since the book title promises a survey from A to Z, we start with…

Beautiful downtown Burbank The shopper's delight

Shady, sheltered pavilions (called "kiosks") to relax in amid lush, green lawns and attractive landscaping; two large play areas featuring colorful equipment for the kids to romp with; soft music as you leisurely stroll from one inviting store to the next—this is the setting of Burbank's Golden Mall, a delightful park-like shopping center in the heart of downtown Burbank.

It's nothing less than a delight to shop in Burbank! 1970. *Mike McDaniel.*

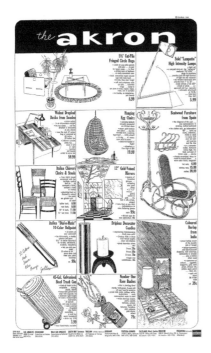

An ad from The Akron, showing the kinds of goods it typically sold, 1968. *Wes Clark*.

THE AKRON (pointedly, not "Akron's")—This "serendipity department store" (as *Women's Wear Daily* called it) was located on Hollywood Way not far from the Magnolia Boulevard intersection. Very mid-century modern in style and a forerunner to Pier One Imports, one could find all kinds of oddball imported goods here. In 1968, Wes Clark's father purchased Wes's very first suit coat at the Akron, a groovy forest green, double-breasted style intended for Sunday church wear. It was found in an aisle next to the African masks. The Burbank Akron store opened in 1955. The *Los Angeles Times* reported that the sign was mounted on a tower that would be visible for miles across the San Fernando Valley. (Was Hollywood Way really that deserted back then?) Burbankers have probably wondered, "What's an 'Akron?'" The store evolved from the Akron Army & Navy Store opened in 1948 in Hollywood. Possibly the founders are from Akron, Ohio?

The authors asked on a Burbank-related Facebook page, "What was the weirdest thing you ever bought from The Akron?" Answers include a bamboo colander, aluminum foil tins for baked potatoes, a 1915 copy of *Sunset* magazine, a hair piece, a fur coat, an aluminum Christmas tree and a crab-shaped brass incense burner, but the winner is Joy Gardner Brill, who purchased Peter Max sheets and an orange-colored lasagna pan in 1970.

ALEXANDER'S MARKET—On Third Street and Magnolia Boulevard. This was a big modern supermarket where Dan the butcher presided over a full-service butcher section. Impressive, gleaming and high-ceilinged, the emphasis here was on the super.

AL'S SPORT CENTER (aka Al's Bike Shop)—On San Fernando Boulevard. This is where Bob Marak got his 1964 Coppertone Super Deluxe Sting-Ray with the Bendix 2 speed. "I saved that bike so someday my son would ride. When he was old enough, I let him try it. His response was 'Dad, I don't like this bike.' I then said let me try it. It didn't turn well like the bikes of today

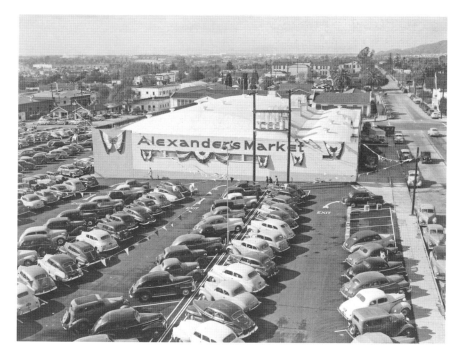

Alexander's Market showing the McDaniel parking spot between the poles. *Burbank Historical Society.*

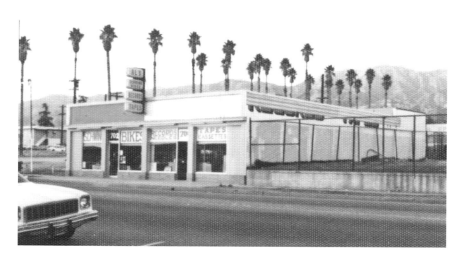

Al's Sport Center with Records Ha next door, circa 1980. *Mike McDaniel.*

and weighed about 50 pounds. We sold it at a yard sale for $200 the next weekend." Right next door was the **RECORDS HAUS**. For whatever reason, the sign on the BHS side of the building was partially painted over, making it "Records Ha," which is what Bulldogs called it. They shopped here because it was close to campus.

BAR'S TV—Before it moved to the big store on Magnolia Boulevard and Hollywood Way, Bar's store was located on Victory Boulevard in the little row of stores at Lincoln Street. Kids delighted in dragging the discarded gigantic refrigerator cardboard boxes found in the rear of the store into backyards for use as spaceships or clubhouses—until it rained, after which it became a sodden tan pile. Interiors were decorated with crayons. Square blocks of paraffin wax could be rubbed onto the cardboard; thus coated, it withstood the rain.

BELA'S VOLKSWAGEN REPAIR—Bela has been keeping the air-cooled Volkswagens in Burbank running for generations. When Wes Clark's father bought a VW Karmann-Ghia, Bela kept it in good running order despite Mr. Clark prematurely wearing down the clutches. Bela kept a sign in his office that read, "I'm fighting poverty. I'M WORKING." Bela also kept ferocious dogs in his yard at night because this was the era of the dune buggy, and Bela had desirable spare transmissions and engines everywhere. He is still in business.

THE BOOKMARK—On the Golden Mall. This bookstore had an extensive World War II section, of interest to boys. The circular spinning rack with the *Ballantine's Illustrated History of World War II* paperbacks was an attraction because the books were an affordable buck each.

BURBANK FORD AND COMMUNITY CHEVROLET—The Ford versus Chevy rivalry is celebrated in American life, especially among truck owners. In Burbank in the 1960s, the rival dealerships were separated by the Olive Avenue Bridge: Chevy at a position nearer to the downtown area on one side and Ford nearer to Victory Boulevard on the other. Sales of Pintos and Mavericks weren't enough to keep the Ford dealership afloat, however, and the triumphant Community Chevrolet moved into the Ford dealership's larger, more desirable facility. It is there to this day.

THE COMMUNITY MARKET—On Glenoaks Boulevard and Cypress Avenue. Burbank kids fondly recall the massive candy section.

ED'S TOWNE SHOP—On the Golden Mall. A haberdasher of choice for teenage males because staff always treated young clientele as adults, ensuring that suits were measured and altered for a proper fit. The suggestions for shoes, shirts and ties made customers feel as if they dressed their best and

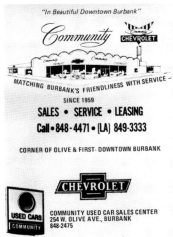

Above: Bar's TV on the corner of Magnolia and Hollywood Way, 1970s. *Burbank Historical Society*.

Left: See the USA in your Community Chevrolet! 1970. *Mike McDaniel*.

looked good. Mike McDaniel had a gold charge card there as a teenager. The business trusted him. (His parents paid the bill.)

ELECTRONIC CITY—Opened originally by star Donald O'Connor in 1957 and closed in 2013, this was the source for electronic hobbyists to get Motorola HEP transistors and other hard-to-find parts.

"ENTER THRU REAR OF STORE"—An interesting feature of shopping in the stores along Magnolia Boulevard was the ability to park in the rear and enter the store through a back door. As one made one's way to the main store area, the flotsam and jetsam of retail sales (extra stock, paperwork, boxes, advertising) were apparent. Kids felt a special thrill viewing that which was not meant to be viewed. Wes Clark remembers a shoe store on Magnolia Boulevard where he used to buy his Hush Puppies, a casual suede slip-on shoe popular in the early 1970s. Walking to the store from the rear

he noticed all sorts of unused advertising items in the back, including a foam hound dog that served as the Hush Puppies mascot. He asked for it and got it, and for years the mournful visage of the Hush Puppies hound dog greeted Wes in his bedroom.

Enter-thru-rear stores were also common on San Fernando Boulevard. As a small child, Mike McDaniel got a thrill seeing stacked boxes of pens and office supplies and, for the longest time, never realized that one could enter through the front of the store. Back in the 1960s, the people who worked at these stores knew you by name and were always happy to see you—a vast difference from today's American big-box store retail scene.

FLINDERS INSURANCE AGENCY—Their slogan has been atop the building since at least the late 1960s: "When you see me, don't think of insurance, but when you think of insurance, see me." Most people regard it as nothing more than a memorable advertising slogan, but for Angela DeTolla Smythe's father, it was an unbearable bit of doggerel; he used to get so irritated by it he'd drive out of his way to curse at it.

THE GOLDEN MALL—You have to give the city planners credit. The Burbank Golden Mall was a bold exercise in forward thinking: six city blocks long and two wide, it incorporated futuristic, hexagonal designs with restroom facilities, fountains and pedestrians-only access to the stores along San Fernando Boulevard. No dirty, noisy cars would ruin the downtown shopping experience. The city's promotional text said it all: "A six-block, traffic-free 'Golden' Mall has been scheduled for construction during 1967....This undertaking has been intelligently designed for pleasurable shopping and browsing in a relaxed and attractive atmosphere." As boys, the authors viewed the signs announcing its coming with the same anticipation they had for the 1967 Tomorrowland upgrade at Disneyland; it seemed to represent a bold vision of forward planning. It was an example of the cities futurists described on television, made manifest in their own hometown to enjoy.

It didn't take long, however, for the dream to sour. Sav-On's cherry vanilla ice cream was great, but too many Burbankers complained about having to park far away from the stores they wanted to visit rather than right in front, as they were used to doing. As 1970s stagflation took effect, the quality of the stores began to decline. Burcal (fashions), Thrifty Drug Store, Sav-On, Newberry Co., Woolworth's, good jewelers and banks—they disappeared one by one. Rather shabby used bookstores began to open in the large spaces where, previously, impressive stores had been found. Even the water in the fountains became dirty, when there was water in them at all. The worst became apparent in the late seventies, when the city opened a job assistance

Flinders Insurance and its memorable slogan. *Mike McDaniel.*

Left: The Golden Mall at the height of its glory, circa 1969. *Burbank Historical Society.*

Right: Kessler Jewelers on the Golden Mall, 1970. *Mike McDaniel.*

office across from Ed's Town Shoppe; the homeless-looking men ambling around the office were hardly the sort of thing the futurists had predicted. Conceding defeat, in 1989, the City of Burbank removed the mall entirely and once again opened up San Fernando Boulevard to vehicular traffic. Business is once again thriving along San Fernando Boulevard.

HUMES SPORTING GOODS, BY BOB PILATOS

A friend and I were outdoor enthusiasts, and so we would jump on our bicycles and ride to Humes on Victory Boulevard. From where we lived, it was a long ride on a bike with no gears. I guess we were in our early to mid-teens back in the mid-1970s. My friend was German and he and his family were outdoor enthusiasts. They were climbers, hikers, campers, fishermen. So, he would call up and say, "Let's go to Humes."…I think I bought my first Buck knife there as I was fascinated with the great wood and brass body. I was there so often, one of the employees knew me by name. It was a great place, with its log cabin style construction, and once inside, it made you feel as if you were in the wilderness. As a kid, I dreamed of owning a lot of the stuff in the store.

JACK MCAFEE VOLKSWAGEN/PORSCHE—For those with a passion for German-manufactured goods, this place was an automotive mecca. The dealership on Victory Boulevard was owned by a successful race car driver of the 1950s and 1960s. Wes Clark Sr. bought a 1965 Karmann-Ghia here. The star of the dealership showroom was a kindly German salesman named Otto, whose signature clothing item seemed to be shiny white vinyl shoes. He was always encouraging to kids, not turning them out for spending too much time sitting in the model cars. Otto told kids to be sure to return when they were old enough to drive. In 1978, Wes Clark returned to buy a Porsche 914 from the dealership but, sadly, not from Otto, who had moved on.

J.C. PENNEY—A legendary Burbank store for a number of reasons: (1) It was the major department store downtown so you couldn't miss it, (2) Debbie Reynolds worked there as a teen and (3) This is where everyone bought Boy Scout and Girl Scout uniform goods. Many boys bought prized items like official BSA pocket knives here, as well as BSA rings and neckerchief slides. Wes Clark's parents suited him up here for his lamentably short career as a Lion Cub Scout; he couldn't sell any popcorn and was accused of cheating at a Pinewood Derby contest, so he quit. Young buyers could

also purchase an item from J.C. Penney's record department that might be regarded as the polar opposite to Scouting goods: Alice Cooper's *Killer* record, which featured a foldout 1972 calendar depicting a bloody Alice hanging from a noose.

JESSUP DRIVE-THRU DAIRY—Remember the calf with the splayed legs on the green logo? Jessup's milk came in glass bottles. There were three stores in Burbank: one on Burbank Boulevard and two on Glenoaks Boulevard.

LEONARD'S—This department store on Victory Boulevard (where the Hobby Lobby is now) had a food court smack dab in the front center of the store as customers walked in. It also had a boys' fashion section with cool bell-bottom jeans for sale. How many boys were forbidden by fathers to wear these in public or to school because they would look like hippies? Some resourceful boys made them at home from old jeans with an added panel.

On one particular day in 1970, the McDaniel family visited Leonard's and saw a big sign advertising bell-bottoms on sale. A hopeful Mike pointed the sign out to his father but got a "Not on my watch, Son" look. He directed Mike to get a soda at the snack place and privately discussed the matter with Mrs. McDaniel, after which Mike's father looked Mike square in the eye and said, "If I let you get a pair for school will you promise not to become a drug-using hippie?" Mike agreed in a heartbeat, and the family then picked out the proud lad's first real pair of bell-bottom jeans. He achieved coolness. Wes Clark's first bell-bottoms—tan, striped, polyester and ugly—were purchased at the Valley Plaza Sears. He never felt cool wearing them, just vaguely ridiculous.

LUMBER CITY—Before Home Depot became ubiquitous, there was Lumber City. Some locals called it "Lumbering City." This was where many tools and building supplies were purchased by Burbankers.

MILLER'S OUTPOST—Where we used to buy our groovy corduroy pants in navy, tan, burgundy, white, light blue, green, gray and brown. Why were cords popular back in the seventies? Perhaps they represented more of a chic casual, organic earthiness than even blue jeans; the earth tones they came in may have helped sales. For some strange reason, the light blue ones got dirtier faster than the white ones. Cords were great: you could eat some food and the moment you put your hands in a pocket for something the efficient cleaning ridges immediately absorbed the grease and oil. Why wash your hands? Miller's Outpost was also the sole source for OP (Ocean Pacific) shirts. Seventies kids loved the hip designs and colors, plus it was cool to have the letters "OP" stitched into the sleeves.

RALPH'S (ON THE CORNER OF VICTORY BOULEVARD AND BUENA VISTA STREET)—Kids have fond memories of the space age–looking old Ralph's grocery store for three reasons: (1) The liquor department, on the right side of the building where the magazines and comic books were kept, was a great place to read comics. Kids could spend an hour or so, sitting by the magazine stand, reading comics that they might or might not buy. Every now and then an irate adult employee could come by and rouse the kids because of the creases magazine covers would acquire by kids sitting on them. (2) The huge, mostly unused side parking lot was where Wes Clark and his friend Richard would give each other shopping cart rides (tearing the basket part off at the welds made a perfectly usable cart for a rider). Pushing the broken cart home, Wes would also give Lincoln Street rides to the girl across the street, Viki. (3) Parents and kids used the same huge parking lot to learn the mysteries of driving cars on Sunday afternoons.

The old Ralph's building had a semi-flat roof that leaked whenever it rained; employees had to put buckets in the aisles all over the place. About the building, Shel Weisbach adds, "The Ralph's was designed by Stiles O. Clements, and with its sweep of windows and arched roof was a great example of 1960s architecture. Clements was a partner of Hearst Castle designer Julia Morgan and did several local Ralph's as well as the North Hollywood Sears at Valley Plaza."

The spring 1965 parking lot carnival was a fond memory. It was the usual traveling thing, seemingly run by tattooed fifteen-year-olds. The ride that all the neighborhood kids talked about was "the Hammer," which made a fearsome sound while putting riders through a 360-degree rotation and holding them upside down for a moment or two. The test of manhood was to endure this ride without vomiting; childhood lore was that the inside of the ride smelled like spewed lunches. When kids finally rode the thing,

Compton Shoe Repair. This is what your full service shoe business looked like in the 1960s. *Postcard, Mike McDaniel.*

they were a bit chagrined to discover that not only did the cabin not smell like vomit, there was little danger of becoming sick. The parking lot circus also featured a very cheesy carnival haunted house in a trailer. When the Disneyland Haunted Mansion opened in 1969, it forever set the standard for what are now called "dark house" rides and pushed such low-budget attractions to the rear.

SECURITY PACIFIC BANK—On Olive Avenue and San Fernando Boulevard. Burbank kids recall noticing how cold the marble counter at the teller window felt on their chins as they stood on tiptoes to watch their parents make deposits and withdrawals.

SHOMAN'S DAIRY, BY BOB THOMASSON

Shoman's Dairy occupied the land near Hollywood Way and Empire Avenue, where the Unimart store was later built. Fry's Electronics is there now. It was a huge part of our neighborhood and also the location for many childhood adventures. The dairy buildings seemed old in the 1950s, and I think the dairy was there for many years. Shoman's Dairy was a small surviving piece of rural America, wedged between the Lockheed factory and suburban residential neighborhoods. There was a small dairy retail store with a driveway on Hollywood Way, with a large sign proclaiming "Shoman's Cash and Carry Dairy" with the price of milk listed like gas station prices. Door-to-door milk delivery was common then, but the only way to get Shoman's Dairy milk was to visit the store.

The dairy store door had an imitation Coke bottle for a handle. Inside were refrigerated coolers filled with milk, chocolate milk, soft drinks and Popsicles. On the counter were Hostess Twinkies. There was a shady knoll out front, with a picnic bench that overlooked Hollywood Way. A private road led past the dairy store to the dairy itself. On the right was a concrete milking barn, with automatic milking machines and drain gutters where the cow manure was hosed away. Other buildings included a concrete silo that didn't seem to be used much. There was also a hay barn, a small maintenance shop and, one of the favorite places for elementary school-age visitors, the employee break room with a pool table. We weren't allowed in but that didn't stop us from squinting through the dirty windows at the pinup girl posters. The rest of the dairy consisted of pasture area for the cows.

One dairy employee was a former boxer named Pedro, who could wrap a chain around his biceps, flex his muscles and snap the chain. Pedro

was a legendary man, worthy of much awestruck discussion between us kids, although I don't know of anyone who personally witnessed the chain breaking.

How many kids had chocolate or strawberry milk for the very first time at this dairy on elementary school field trips?

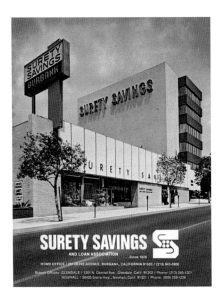

The Surety Savings building on 237 West Olive Avenue. *Mike McDaniel.*

The Unimart building, early 1960s. As kids, we used to call it Unimart fall-apart. *Burbank Historical Society.*

SPECTOR'S MARKET—Back in the 1960s, if a market was named "Spector's" you could reasonably assume that you might encounter somebody surnamed this. Mr. Spector was a neighborhood store personality who dispensed mercy for kids caught stealing candy and reprimands for teenagers spending too long looking at the car magazines available near the front door. The store also had a tube tester located next to the chicken rotisserie, which many electronically inclined do-it-yourselfers used to troubleshoot bad 12AX7s and 6L6s.

Spector's was also a source for liquid chlorine and muriatic acid. Getting a gallon of pool acid safely delivered to the backyard via Schwinn Sting-Ray was a tricky proposition, as the bottle always seemed to leak a little, outgassing horrible fumes. What sort of parents tasked boys to transport toxic chemicals?

UNIMART—Like Zodys, another great example of distinctive space age architecture, the Burbank store was opened in 1962. When it closed down in the late 1960s or early 1970s, the building was purchased by Lockheed. Unimart replaced Shoman's Dairy.

VILLAGE BICYCLE SHOP—On Magnolia Boulevard. This was the source for the Schwinn Sting-Ray, the nearly universal form of transportation for Burbank kids in the 1960s. Many of these kids, upon breaking some minor traffic law, shamefacedly found themselves in the Burbank Police Station on a Saturday morning watching a 1956 film featuring Jiminy Cricket singing a song about not being a fool and living to age 23, 33, 53, 93 or 103. Going to this shop was usually a matter of embarrassment for some non-mechanically inclined kids, as it meant that another flat tire had to be repaired. Flats were often a result of foolishly riding bikes in the then-vacant lot along the Lockheed wash at the end of Lincoln Street; the pointy stickers from the weeds there easily punctured the tubes in "slik" tires. In 1968, Wes Clark received a metallic blue five-speed Schwinn Ram's Horn Fastback from the Village Bicycle Shop; it was stolen in the first week or two from the bike rack at Luther Burbank Junior High School. Burbank detectives were put on the case and eventually found it, battered and badly damaged.

Some Burbank kids could not afford a real Schwinn brand Sting-Ray. The option then was to buy an inexpensive vintage bike and some genuine Schwinn accessories for it at Pep Boys. Popular items were banana seats in black with silver sparkles, extended "sissy bars" with diamond headrests, new tires and hand grips. With a spray can of ultra-flat black spray paint, boys could disassemble the bike and strip the old paint off and then paint the frame and mount the accessories. These looked fantastic!

ZODYS (no apostrophe here, either)—Another puzzlingly named store. According to Urban Dictionary, a *zody* is a couple who are astrologically attracted to each other or a musician who can't keep time, but the authors think it refers to a surname. Burbank's Zodys was located on San Fernando Boulevard—the building still stands. Architectural firm Ainsworth, Angel and McClellan came up with what the *Los Angeles Times* called a "space-age design," referring to the unique, tilt-up poured concrete blocks. Surfaces apparently were formed by workers pressing their hands on a piece of plastic upon the concrete before it solidified; the claim was that the technique saved a minimum of two weeks in construction time. The Burbank store (the seventh in the Southern California chain) was opened in time for the Christmas 1962 sales push. Wes Clark Sr., seeing the costumes worn by the cast of *Star Trek*, memorably asked, "Why are the spacemen wearing Zodys pajamas?"

There were undoubtedly other favorite places to shop in town way back when. What were yours?

Santa arrives by helicopter with Broderick Crawford, John Astin and a master of ceremonies—Zodys's opening day in 1962 was a big deal! *Burbank Historical Society.*

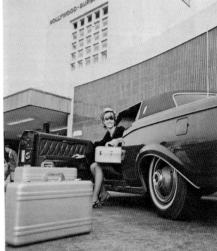
A pretty lady arrives at the Burbank Airport in her Lincoln Continental with her space age aluminum Zero Halliburton luggage. *Mike McDaniel.*

Fondly remembered businesses no longer in business: the slot car tracks (Burbank Motor Raceway, Speed Circuit Raceway), the Fun Jump, Mode O' Day, Jim's Used Things, Burcal, the Hustler, Magic Muffler (and their purple 1956 Chevy Nomad), Photo Art Shop, Bishop of Burbank, Ken Sproul's Bowling Supply, Rothe Pontiac, Tom Neal Oldsmobile, Cinema Lincoln Mercury, Burbank Speed Shop, Shalda Lighting, Sturdy Dog Food, Bill's Ranch Market, Dreese Vacuum Cleaner Shop, Stansbury Buick, Mike's Auto Parts, Wanamaker Rents, Killeen Music, Mayfair Market, Fazio's Market, Market Basket, Community Market, the old Elks Lodge (the city morgue was next to the kitchen), Winston Tires headquarters, IERC, Burbank Surplus, Little Stores, Al Rediger's service station, Mel's Militaria and Antiques, Naha's, Thom McAn shoes, Bud's Flowers, Lyons Men's Shop, Jim's Gold Shop, Kessler Jewelers, F.W. Woolworth Co., Morey's Shoes, Kinney Shoes, Red Wing Shoes, Kay's Liquor, Burbank Dodge, O.K. Used Cars, Food Giant, Dotty Lee's, the Shopping Bag, Terminal Refrigeration, Bethanis Furniture, Kelly's Pool Hall, Studio Men's Shop, Newberry Beauty School, Maler's, Hank's Men's Clothing and Bush's Stationery.

The Burbank Unified School District

School days, school days/Dear old Golden Rule days. Is there anything more evocative of the past than one's childhood experiences, for better or worse, at school?

What was it about the Burbank School District that was "unified?" Burbankers found this somewhat puzzling. A 1967 history of Burbank printed by the school district explains it: "The Burbank Union High School District and the Elementary City School District were united in 1927 and became the Burbank City School District with a City Board of Education and a City Superintendent of Schools. Then in 1928, the name of the system was changed to the Burbank Unified School District."

ELEMENTARY SCHOOL DAYS IN THE EARLY 1950S, BY JULIE GRIMM GREGG

My memories are a bit fuzzy because I lived in Burbank only from birth until the end of fifth grade in 1954. Those were formative and impressionable years. My father worked as an engineer for Lockheed, and our family lived on Parrish Place, Clybourn Avenue and Lamer Street—as each additional child required a larger house. At the time of the move to the house on Lamer Street, in 1948, ours was the last block of houses into the foothills, and what happy memories I have of exploring the nearby vineyards as far as the eye could see. It was not unusual that a brush fire would creep

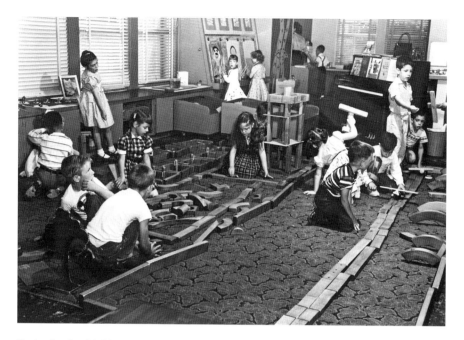

Burbank schoolchildren at play in class, 1950s. The boy at left is wearing a Mickey Mouse Club T-shirt. *Burbank Historical Society.*

too close for comfort, though as a few more years went by, more blocks of houses, marching up Lamer Street, pushed back nature. The front yards were playgrounds for emulating our hero Hopalong Cassidy, and we played ball at our peril since a rubber ball would sadly get away, pick up speed and be gone forever down the Lamer Street hill, never to be seen again, alas! We had an incinerator in the back yard for burning trash, as did everyone else. The Helms (bakery) man came, the milkman delivered, the ice cream trucks came and the Fuller Brush man visited.

Even at age five, I walked to George Washington Elementary School alone, under the watchful eye of the grandfatherly crossing guard at Glenoaks Boulevard. Little girls came to school with their milk money from home tied in a hanky and pinned to their dresses. Once a week, we put quarters in our Bank of America bank books; these eventually paid dividends! In first and second grades, three classmates were stricken with the dreaded polio virus.

In third grade, the day came when the old-fashioned rows of desks were carted away and replaced by modern stand-alone ones without inkwells! On the playground, our hands became callused from swinging from steel rings and crossing bars, and games of hopscotch went on for years. In the

Left: Joaquin Miller Elementary School, 1968. *Mike McDaniel.*

Below: The student body of an unknown Burbank elementary school, 1950s. *Burbank Historical Society.*

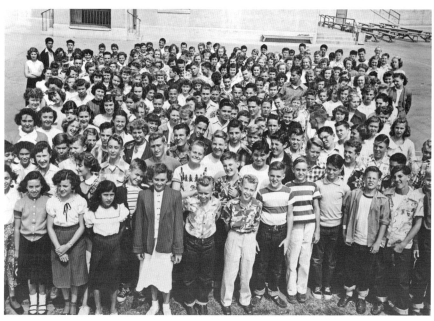

upper grades, recess was a time to exchange trading cards, play marbles on the dirt field, and pretend to be pioneers trekking west, as many of our forefathers actually had. The May Festival was the high point of the year, when we classes danced our way through the Mexican Hat Dance, the Lili Marlene, the Tarantella, and the Virginia Reel (to name a few). Sadly for me, I left Burbank before having the privilege of weaving the May Pole at Washington School as a sixth-grader.

Schoolyard Murder Tale, by Angela DeTolla Smythe

I remember as kids we would walk around the edge of the wooden planter boxes that surrounded the top most level of the playground up at the corner. As we walked we would recount the story of the awful thing that happened "…in that empty white house over there"—a woman had been killed and they found her with both of her legs cut off. Who it was and where it started I don't remember, I just distinctly remember a bunch of us girls recounting the story…we also used the planter boxes to play with our trolls! It was a girly thing!

Note: A search of the *Los Angeles Times* archives contains no such murder/amputation account.

Pioneer Trek at Miller Elementary

Burbank elementary schools offered fun and interesting special events. One such was the Miller Elementary Pioneer Trek on the lower (dirt) play area. A big deal, this took weeks to prepare for and involved costumes: bonnets for the girls and vests with leather ties for the boys. In those days, most of the boys owned their own cowboy hats. Radio Flyer wagons were used as Conestoga wagons, and a fire was built on one end of the lot; a pot of beans hung via a metal framework over the fire. Boys got to wear their Mattel Fanner 50 cap pistols in holsters and brought Ricochet rifles. The kids paraded around the play area and repelled an Indian attack. The wagons were circled around the campfire and lunch—beans and hot dogs—was eaten. Each boy had a wagon, a girl who played his wife, and both had scripted parts to recite. Kids recall that it was one of the best school days ever at Miller.

DARK SHADOWS

A feature of school for millions of kids nationwide was making it home by 4:00 p.m. each day in time to watch *Dark Shadows*, the ABC-TV soap opera starring Barnabas the vampire, Quentin the werewolf and, especially, Angelique the witch with the gorgeous big blue eyes. Composer Bob Cobert's moody and evocative musical cues became just as much the music of the times as any of the hits played on the radio, and when a soundtrack album was released in 1969, it became a hit.

PEE-CHEE FOLDERS

From Wikipedia:

> *The yellow Pee-Chee All Season Portfolio was a common American stationery item in the second half of the 20th century, commonly used by students for storing school papers. It was first produced in 1943 by the Western Tablet and Stationery Company of Kalamazoo, Michigan....*
> *The illustrations usually depict high school-age students engaged in sports or other activities. Artist Francis Golden, best known for watercolors of*

The ubiquitous Pee-Chee folder. You may do your own scribbles here for old time's sake, if you like. *Cari Clark.*

fishing and hunting, drew the illustrations starting in 1964. It became popular for students to deface these figures, often with scurrilous doodles and thought balloons.

The usual artistic impulse involved enhancing the illustration of running athletes to include drawn daggers and voice balloons marked "Stop thief!" The 1974 Burbank High School *Ceralbus* yearbook was designed after the style of one of these folders.

"THAT'LL LEARN YA"—CORPORAL PUNISHMENT

Luther Burbank Junior High School students have a vivid memory of the aluminum (!) yardstick Mr. N. used to deliver a swat on the behind to noisy students in his seventh grade art class. And then there was the teacher who had transferred to Luther Burbank from teaching at a community college and was unused to junior high school–aged males. Seeing the necessity of inflicting corporal punishment, but not wanting to do it herself, she subcontracted it out to a loud and aggressive boy in the class. One boy, receiving an enthusiastic blow to the behind on one occasion and feeling injustice along with physical pain, complained to his mother. The story was that the principal and the teacher learned a thing or two about angry parents.

HIGH SCHOOL

During the Baby Boomer era, Burbank schools were set up differently from elsewhere in the country. In other states, junior high is called middle school and is only two years, seventh and eighth grade. High school starts with ninth grade and ends with twelfth. But back in the 1960s and 1970s in Burbank, junior high was three (painful) years and high school was also three years. Many students felt cheated out of a year of high school under this plan. Burbank has since switched things to follow the more general system, and Luther Burbank is now called a middle school.

Junior high seemed to be mostly about picking up your Pee-Chee folder after some idiot knocked it to the ground and sex ed. Physical education (PE) and group showers were an unpleasant development for most. The best thing to bring readers back to the days of junior high is to re-watch the first three seasons of *The Wonder Years*, which nailed it.

Earlier on, we described the hillside Burbankers (professionals and semiprofessionals living in large homes on the Verdugo hillside north of Glenoaks Boulevard whose kids mainly went to Burbank High) and flatlander Burbankers (the working class living on the valley floor in smaller homes whose kids mainly went to John Burroughs High)—rival high schools divided by socioeconomics as well as geography. Each year, this rivalry was fought out in the homecoming football game, known colloquially as the Big Game. The Red versus the Blue has always drawn crowds, and Burbankers have fond memories of those battles.

Burbank junior high schoolers and high schoolers divided themselves by cliques:

AV Nerds—Before schools had personal computers, digital downloads and the Internet, there were audio-video departments manned with kids. These were the students who came to your classroom to run the movie equipment or use the huge videotape camera to record pupils presenting their book reports for the teacher's and class's later critique. Often these same kids were in the chess club, math club or nascent computer club. While there were nerdy girls, young women never ran AV equipment.

Band Kids—Band members were their own kind of nerdy. Completely separate from the Drama Freaks, the band kids worked hard on marching for football games and making music together. They could break into Chicago's "Feelin' Stronger Every Day" or the school fight song at the drop of a hat.

Drama Freaks—These kids had visions of nearby Hollywood dancing in their heads and were much more unique and creative in their dress than anyone else in the school. Perpetually singing, trading lines from plays and always on stage in the school musicals, one could spot them a mile away. Everyone else found them irritating, so this was probably the most exclusive clique of all.

Everyone Else—The great majority of kids didn't belong to any single group. They might take an AV or music class to fulfill a requirement, but never took on any particular persona. They just got their work done and met their friends for lunch.

Jocks—These were the stars of the high school. Back in the seventies, before Title IX, there were no real girl jocks; cheerleaders were the distaff wing of the jock group. They were handsome, All-American types, confident in their perch at the pinnacle of the school hierarchy. Recognizable in their letterman jackets, the basketball players were tall and skinny, the football

A Burbank student connects Frankensteinian dials to an old car in Auto Shop, 1950s. *Burbank Historical Society*.

players were intimidating and the water polo guys were just fit overall. There were also tennis and track jocks—soccer was not yet the popular sport it is today. They all had the same it's-great-to-be-me stride, their books hanging at one side in a cupped hand. They never had their Pee-Chees knocked out of their grasp.

LOW RIDERS/GREASERS—This was the sullen, not-easily-disciplined set. They usually smoked off-campus and wore dirty jeans and T-shirts. The girls wore a lot of makeup and were tough rather than sweet. Less law-abiding than surfers, they were always ready for a fight—or at least appeared to be. Note: Low-riders didn't drive low-rider cars in Burbank. This was more of a Los Angeles thing. The terms *low rider* and *greaser* were more or less synonymous.

SOSHES—A word adapted from "social," pronounced "so-shezz," this group of driven, popular kids had lots of friends and seemed destined for success. The student body officers came from this group.

STONERS—These kids seemed to be high all the time. They wore untucked plaid flannel shirts and slumped in seats in the back of the classroom, seldom participating (especially after lunch). The drug of choice was marijuana,

but they talked constantly of using other mind-altering substances, as well. This being California, peyote and "magic" mushrooms were also common indulgences, the thought being that these natural highs were more authentic and safe than man-made chemicals. And frankly, Burbank kids usually didn't have the resources for expensive drugs.

SURFERS—These were easy to spot. They had sun-bleached hair, wore puka shell necklaces and Hang Ten or Hawaiian shirts and seemed to speak their own jargon, mostly of words describing enthusiasm or surf conditions. The skateboarding culture hadn't quite yet taken hold in the early seventies, so it was mainly the Pacific Ocean and waves with these kids. Jeff Spicoli in *Fast Times at Ridgemont High* (1982) forever captured the 1970s archetype, albeit the stoner subset.

1947 BURBANK HIGH SONG

BHS Bulldogs were inheritors of a high school legacy going all the way back to 1908, when the school was formed. But growing up, the school's administrators never passed on this kind of lore—according to Dodie Moore, Burbank High students from 1947 sang this song to the tune of "The Caissons Go Rolling Along (The Army Song)":

> *Give a cheer, give a cheer, for the boys who make the beer,*
> *In the cellars of old Burbank High.*
> *They are brave, they are bold, and the liquor they can hold,*
> *Is a story that's never been told.*
> *For it's guzzle, guzzle, guzzle as it trickles down your nuzzle,*
> *Drink up and never go dry!*
> *So have one more, as the cops break down your door,*
> *In the cellars of old Burbank High!*

How long did this song persist? By the time 1971 came around, it was unknown.

THE BULLDOGGETTES, BY JERI MORIN VALENCIA

We played girls' high school softball for Burbank High. 1974 was the first year that Burbank entered into the girl's softball competition and it was 1975 when Burbank High became champs for the record books. We

SPIRIT FOR 1972 **VS.** PRIDE FOR 1972
BULLDOGS 1972 INDIANS
BURBANK · BURROUGHS

Spirit vs. Pride! A page from the 1972 Burbank High versus Burroughs High Big Game program. *Mike McDaniel.*

were not supposed to be anything to anyone that year. The papers called us the Cinderella Team. We were lower than the lowest as far as any kind of threat to the competition. But one thing everyone didn't count on…we all liked each other! We didn't have any kind of any crap going on because we ALL loved each other, basically. All the other teams were just teams, but Burbank High was a family. We were all doing what we LOVED and we were doing it together, with each other. It is truly a blissful memory I hold in my heart.

At the 100th anniversary of BHS event in 2008, since we were Softball CIF Champs for 1975, we were invited to march in a little parade in front of the school. We hadn't seen each other in such a long time and then, the parade. It was COOL! There were little kids on the sidewalk waving to us like we were something special.…I'll never forget that! Thanks, Burbank High!

WALKING HOME FROM SCHOOL

Walks home from Burbank High School for kids living off Victory Boulevard were minor adventures. The trek started by walking down Burbank Boulevard, past the enormous and impressive Home Savings Bank building. Was there a more impressive financial institution in town? No! So many Burbank kids opened their first bank account there. The Toyota dealership was across the street. Back then, people raised with big American cars looked though the showroom window and wondered, "Who would want to buy one of *those* things?" In the early 1970s, Toyotas were off-brand, oddball Japanese constructs—when the Honda CVCC came out, witty teenagers called them "Crap Versus Cheaper Crap." How things change!

The next stop might be the Dip, a pastrami sandwich shop at Burbank's infamous Five Points. The Sweetheart of the Five Points was Gail Ptack, an attractive young woman who worked the counter with her brother Paul Rosen. Gail had great legs and moved like a dancer because she was a ballerina. Burbankers who fondly discuss the Dip on Facebook groups all agree, she was a doll with a lovely and kind personality. Gail was married to a Burbank cop, so hands off. Her brother Paul had an outgoing personality and was a pal of many of his customers.

A great thing about the Dip was the presence of Pete, a grumpy Lockheed retiree who sat nearly every day at the picnic table on the side of the building, under a metal awning. A man of infinite world-weariness and disgust, his usual comment was "Ehhh…"—uttered with a dismissive wave of the hand.

7
A Taste of Burbank

People have to eat, and one of the blessings of civilization is dining out. Here's a partial collection of the Burbank places where Baby Boomers ate. It excludes restaurants outside the city boundary, so as much as the authors would like to spotlight the comically named Los Angeles Chinese food restaurant Men Hong Low, we cannot. Burbank only.

FEATURED RESTAURANT: THE CHOPSTICK

This was a legendary 1970s Chinese food restaurant on Alameda Avenue near the Disney Studios. When the authors were social lions in their early twenties, they used to take their fiancées and friends there. The first thing of note was the waiter, a thoroughly miserable man who seemed to resent customers. Here's a few remembrances from a Burbank Facebook group: "He had the personality of a run-over rattlesnake"; "We called that waiter 'Smiley'"; "The old guy who ran the place NEVER smiled and would growl and grunt at us when he took our order"; "Yuk…the waiter had a HAIRY MOLE on his neck…really long hairs!!! and his stench was the worst."

There's no substitute for a good first impression, is there?

Aside from the waiter, the Chopstick was primarily known for warm Coke (asking for ice resulted in the waiter giving you the evil eye), the fried shrimp and…some other animal. The Chopstick was caught with a dead cat in the freezer by the public health officials, and the place was closed down for a while.

Upon leaving, the authors' party trick was to stick a cast-off cigarette butt in the mouth of the Buddha located outside the front door—it looked hilarious and never got old.

The Chopstick is no longer in business. (Surprised?)

MEMORIES OF SARGENT'S, BY DUANE THAXTON

I worked there sometime around 1965 to early 1967. I think my hours working there were daily, 5 pm to 9 pm, except I think they were closed on Mondays. Working there pretty much killed my high school social life. I remember Mavis and Graham, the owners, and a cook named Scotty (glasses and mustache) who cooked fish orders. There was at that time another cook, a Blackfoot Indian—I've been told his name (or nickname) was Chick...and that sounds correct to me. There was a younger waitress who had married a Marine who was down at Camp Pendleton.

I remember sweeping up after they closed. If I were to find a penny I would hand it to Mavis...[and] she would thank me and put it in the register. Mavis and Graham were both pretty strict and frugal.

I remember Mavis had one eye that was out of whack. I remember when talking with her I would stare at one eye, then the other, back to the first....I'm sure she realized I was curious about her crooked eye.

Wes Clark's mother worked at Sargent's from 1969 until it closed in 1971. The place was designed with a backwoods/hillbilly theme; the menu items were phonetically spelled and were sometimes difficult to understand. The hushpuppies, southern fried cornbread, were delicious, as was the food generally. The waitresses all had to wear calico aprons. There were lots of antiques in this restaurant, and a gigantic grandfather clock that looked very much like the grand one on *Dark Shadows* stood just inside the door.

Sargent's was replaced by the Grenada Restaurant, serving Mexican food. With a few architectural changes, the business went from the Ozarks to Mexico City.

Opposite: Sargent's postcard. A theme restaurant unlike any other. *Wes Clark*.

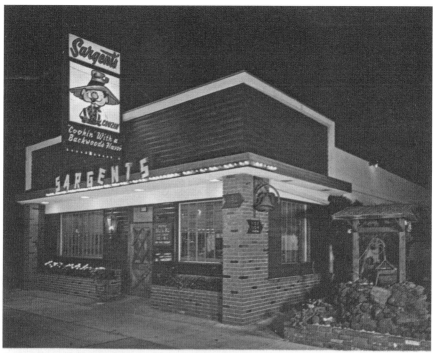

OTHER RESTAURANTS OF NOTE

A&W ROOT BEER—This eatery was at the intersection of Victory Boulevard and Frederic Street, where the omelet shop is today. In 1965, it had draft root beer in paper cones that was to die for. And carhops! Why can't we have that sort of thing once again?

ALBIN'S DRUG STORE—Due to its prominent spot on the corner of two major roads (Hollywood Way and Magnolia Boulevard), this was a favorite shopping place for Burbankers in the 1960s and 1970s. Every Friday night while Wes Clark was stationed at Camp Pendleton and made the weekend drive back home, he and his father would have dinner at the counter in the back. He recalls wondering at the time if life would ever change from this routine; now he wishes he could have just one more meal and chat with the old man. The lesson of Albin's Drug Store is to never take loved ones, or drugstore lunch counters, for granted.

Albin's Drug Store on Magnolia and Hollywood Way, 1960s. *Mike McDaniel.*

BASKIN-ROBBINS—The store on San Fernando Boulevard has been there since at least 1965. It used to be run by the Ratner family: father, mother, groovy son and hazel-eyed daughter. The mother was wonderful, Burbank's Most Compassionate Jewish Mother. When Wes Clark announced in 1974 that he was enlisting in the U.S. Marine Corps, his surrogate mother fretted and worried about him until he got discharged four years later.

THE CHINA TRADER—A celebrated nightclub for adults on Riverside Drive owned by Jack Webb, and the birthplace of the Hawaiian Eye cocktail. From a jazz blog article by Steven Cerra:

For years, composer, pianist and vocalist Bobby Troup held forth at The China Trader. He and his wife, actress and song stylist Julie London, were residents of Toluca Lake. Since his piano was already stationed in the lounge, Bobby could and did walk to work on some of the nights he appeared at The China Trader. Throughout most of the 1970s, Bobby and Julie were in the cast of the hit NBC TV show, Emergency. *The popularity of the show only served to enhance the gatherings at The China Trader when Bobby was appearing there. Bobby appeared solo on Thursday and Sunday nights and with a trio on Friday and Saturday nights. Given his low-key temperament, unassuming personality and acerbic wit, Bobby always kept the atmosphere in the bar relaxed and cordial. Julie dropped by occasionally and when she did, there were always numerous pleadings for her to sing, but she rarely did.*

The Copper Penny—A chain restaurant/coffee shop on Olive Avenue near the NBC Studios. The menus were large, circular and plastic and were molded to look like pennies. Mrs. Clark (who worked as a waitress there in 1967) brought one home, once. They made effective tactical Frisbees. Wes learned this when he bounced one off the head of a friend who didn't duck in time.

Don's—On Glenoaks Boulevard, with a big neon chef (a curious icon from the 1960s) atop the roof. Wes Clark's parents made a practice of eating their Sunday breakfast at Don's. The breakfasts at Don's were expansive. The Sunday *Los Angeles Herald-Examiner* was spread out all over the table, and the family read while waiting for their food. They knew all the waitresses by name and felt like visiting royalty.

The fondly remembered Don's.
Mike McDaniel.

Frank's Restaurant—Jim Baldridge wrote, "My dad was a regular back in the mid 1960s and 1970s and used to take me and my brother there almost every weekend...we loved the food! Cheap, basic, diner classic stuff. I'll sure remember those pancakes with Dad on Saturday mornings....They always were the best!" Now Frank's isn't so much a restaurant as it is an occasional set in the television shows *CSI: Las Vegas* and *Justified*. *Justified* takes place in

Kentucky, but one episode opens with a murder in an alley off First Street and Magnolia Boulevard; the Burbank Water and Power building is seen in the background. There's another killing at the Sizzler on Hollywood Way, and a later scene shows actors eating in Frank's, with a shot in the parking lot. Then it's down to the Doughnut Hut on Magnolia Boulevard where the actors—both portraying bad guys—remark how they have enjoyed the doughnuts ever since they were kids. Ha!

F.W. WOOLWORTH'S/J.J. NEWBERRY—These legendary American five-and-dime stores had locations in Burbank, and these locations had lunch counters that are a fond memory for many, with a mirrored back wall at Woolworth's and all the cool metallic menu signs attached to it, as well as the red vinyl stools. How many downtown Burbankers ate lunch at one of these?

GENIO'S—A favorite spot for Burbankers and greatly lamented when it closed. Burbankers have fond memories of the fine steaks they served with large baked potatoes slathered with butter. Genio's had a Pong video game in the waiting area that was a real novelty in 1975–76. This restaurant had an unbeatable ambiance; it was darkened and quiet—and the food was consistently good.

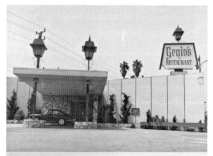

Four views of Genio's. *Burbank Historical Society.*

HUGHES MARKET (ON SAN FERNANDO BOULEVARD)—This grocery store was a Burbank High School hot spot. The bakery had those shortbread cookies with the big dollop of chocolate in the middle. Heaven in every bite.

Best Airport Food Ever, by Tim Avery

I grew up in Burbank, California, before California got its "k." We were under the departure path of runway 15 for what was then called Lockheed Air Terminal. Lockheed Airport still sounds better to me, and when flying down there I still call it that. I always wondered as a little kid how those Constellations ever flew, they were so big. My favorite restaurants as a boy age seven were Bob's Big Boy and the Tick Tock, both on Riverside Drive. The Tick Tock got its name from the 200-plus clocks in the place, and on the hour the place came alive with cuckoos and bells of all sorts.

My all-time favorite restaurant was the Sky Room on the second floor of the Lockheed Air Terminal. If you got a window booth then life was at its finest. Night operations at an airport for a seven-year-old boy were just the best. (You have to remember that Lockheed was the busiest airport on the west coast back then.) To watch the DC-3s and Connies take off at night was a delight.

Santoro's Subs, by Rob Avery

I can tell you personal accounts of working at Springer Company, leaving work early, picking up a large meatball-and-cheese from Santoro's, and driving to Dodger Stadium to work in the parking lots. The guy at Santoro's kept a Dodger home game schedule in the back and knew that I would be there for my large meatball-and-cheese at 3:30 pm for every weekday home game.

THE INTERNATIONAL HOUSE OF PANCAKES—In the 1960s, these were distinctive, tall-roofed chalet-style buildings with signage inspired by early American design. The restaurant on San Fernando Boulevard still stands as an IHOP, but the interior distinctiveness has been remodeled away. In the early 1960s, the "Pancake Man" Hal Smith (Otis the town drunk on the *Andy Griffith Show*) used to sing on a kid's KTLA morning television show, "The Pancake Man/the Pancake Man/Here I am, the Pancake Man/Got

to hurry!/Time to go!/See you on tomorrow's show/At the International House of Pancakes!

JACK IN THE BOX—The one at the intersection of Buena Vista Street and San Fernando Boulevard was the one that got all the attention from the authors in the 1970s. Fun fact: There used to be a standard quarter-inch jack in the speaker box hidden within the collar of the clown, where one stopped to give one's order. If you plugged in a microphone and gave your order through that, rather than depending upon the microphone that was normally used, you blasted the volume in the store and could hear your voice all the way to the car. The authors used to drive the staff crazy deafening them with that little trick.

His Royal Majesty King Swede on Magnolia. *Mike McDaniel.*

KING SWEDE SMORGASBORD—On Magnolia Boulevard and Niagara Street. Home of the worst gelatin dessert, ever. Rubbery and tasteless. Others, however, have fond memories. Corey Fredrickson: "I loved the accordion player in his lederhosen and his alpine hat with a pheasant's feather in it!" Peggy Peters: "We ate many a meal there growing up, and I loved listening to Dad talk Swedish to the beautiful young blond waitresses!" Deborah Johnson: "I think my stepdad put them out of business with all he ate." Chuck Herron: "I have great memories working there during high school, 1962–1964. As teenagers we all pigged out on the meatballs and sweet Swedish bread! Most of the waitresses were sponsored by the Zanders [the owners] and were actually from Norway. I'll never forget Liv, she was a real character! She would let me borrow her 1958 Chevy Impala convertible to go down to Balboa during Easter week. What a different world it was back then!"

THE LONDON BUTCHER SHOP—The best hot roast beef sandwich in town!

MCDONALD'S (ON SAN FERNANDO BOULEVARD)—This particular store was an especial haunt of Burbank High School students, being close to the campus. And eating at a chain restaurant like McDonald's was a novelty back then. As the bomber crewman observed in the film *Memphis Belle* (1990), it's comforting for people to get the very same food coast to coast.

MR. BIG BURGER—Long before chains like McDonald's, Wendy's and Burger King took over the market, one would get a hamburger at a place like this. And the food here was delicious—so much tastier than burgers today. It was a classic taste that, recently, the chain Five Guys has brought back as

Textbook greasy spoon: Chief's Diner on Hollywood Way. *Burbank Historical Society.*

You deserve a break today at the McDonald's on San Fernando Boulevard. *Mike McDaniel.*

a direct reference to individual places like Mr. Big Burger. Why did burger joints this good ever go out of business?

RICO'S PIZZA—On Glenoaks Boulevard. This was a favorite Monday night haunt of Wes Clark and his mother during his horrible junior high school years. They would meet with another Sargent's waitress and her daughter Angela. It redeemed the always unendurable Monday at school.

SMART AND FINAL IRIS—A restaurant supply store with a funny name. Why list it on an enumeration of Burbank eateries? Because the great majority of the local restaurants used to get supplies from this place. When you were eating vegetables at the Tallyrand, you were probably eating Smart and Final Iris vegetables. When you grabbed a candy bar from the counter at Bob's Big Boy, it probably came from there. Those delicious scrambled eggs at Vern's? Yes, Smart and Final Iris. They were the unspoken ingredient in most Burbank staples and delicacies.

VAN DE KAMP'S—A chain restaurant on the corner of Victory Boulevard and Olive Avenue. The primary interest here wasn't the food, it was the building. Designed to look like a Dutch windmill, it had rotating mill blades that were lined with neon tubes. But here's where it got interesting: the tower with the blades also rotated 360 degrees on a vertical axis. There were windows at the ceiling that allowed diners to view the rotating blade ends making their way around the inner circumference of the more or less circular building. Like Unimart, the Buena Vista Street Ralph's, Zodys and the Akron, it was another example of fascinating Burbank architecture.

The best is saved for last:

THE LINCOLN CAFÉ

Adjacent to the Lockheed B-1 plant on Lincoln Street and Empire Avenue, this was the Clark family business from 1974 to 1986. Burgers, hot dogs, beer and sandwiches were served there, in addition to (as Burbankers still recall) considerable attitude from Mrs. Clark if you crossed her.

The story of the Lincoln Café is rife with tales. Here are some highlights:

Every Friday night, when Wes Clark drove home for the weekend from Camp Pendleton, he used to have the same conversation with one of the inebriated regulars: "Hey, Wes, how are ya?" "Fine, thank you." "Where you at, now?" "Camp Pendleton, in the Marines." "Oh, yeah. You been there long?" It didn't vary significantly from this for years. Staggering drunkenly to his car, the question was asked, "How does he make his way home at

Mrs. Clark serving customers at the Lincoln Café's 1974 Christmas party. *Wes Clark*.

night?" A veteran Lockheed worker's reply was, "Hell, some of these guys can't get home without a six-pack in 'em!"

One warm day, an old woman wrapped in a wool blanket walked up to the bar and asked for a 7-Up. Stating, "Phew, it's hot today!" she unwrapped the blanket to reveal that she was wearing absolutely nothing underneath. It was kindly suggested that she leave.

The old building was a constant repair problem. Once, a customer was sitting at the bar when a big drip of water from a leaky roof extinguished his cigarette. This resulted in general hilarity. From that point on, customers stuck under the hole in the plaster were offered an umbrella in rainy weather.

Since the building was originally a residence, windows were everywhere you wouldn't normally want windows in a place of business. When the health inspector came by for his initial visit, he suggested that the window between the men's room and the eating area be closed. Mrs. Clark, playing him along, innocently asked, "Why?" "Well…*sounds*," he responded. He then congratulated the Clarks for the general thorough clean-up and left, and we new owners laughed long and hard.

From 1974 to 1986, the Lincoln Café was broken into at least twenty times. The plunder was always the same: as many cases of beer and as many cartons of cigarettes as could be quickly removed. Once, the thieves got into the bar and out again by shimmying down a narrow gap between buildings and entering through a window. The rope they used to pull up the cases of beer was left on the roof, which enabled the Burbank police to solve the riddle of technique. The proprietors prevented this from ever happening again by installing thick metal bars across the window. Not only did this solve a security issue, it also gave the ladies' restroom a certain 1950s chicks-in-prison film look.

The café used to get incredibly busy during the half hour Lockheed workers got for lunch, and the short order cook loaded the grill with hamburger patties and served them out as many as four times in twenty minutes or so. *Saturday Night Live* premiered in 1975, and the Greek diner skit, the one where the help translates every order, no matter how different, into "Chee-burger, chee-burger, Pepsi, Pepsi!" was popular. Nothing would send a hurried Mrs. Clark over the edge faster than the Lockheed wits coming in during a frantic half hour, repeating this faddish new line at her.

Mr. and Mrs. Clark used to bicker endlessly at the café, and it became a kind of sport for the customers to make the situation worse by pointing out when one was doing something the other disapproved of. It became one of Burbank's best customer-involvement floor shows.

The Clarks didn't need to worry about business. Mrs. Clark, having loads of in-your-face waitressing personality, transferred her clientele from the Alibi (a place down the street she managed before it closed) and made new customers as well. The Lincoln Café was a little goldmine. In 1986, the Lincoln was sold, and the new owner reopened it as Rocky's.

Fondly remembered eateries no longer in business: Kiko's, Vern's, Shugie's Deli, Perrens Deli (Golden Mall), Pup n' Taco, Foster's Freeze, the Blarney Stone, Whiskey Bend, Der Weinerschnitzel, the London Butcher Shop, Piggies Sandwiches, Orange Julius, the Pizza Pie, The (Original) Great Grill.

Kiko's Mexican Restaurant, 1970. *Mike McDaniel.*

8
Leisure Time

Burbank has always had a great parks system, and Burbankers loved to take advantage of the various tree-filled facilities. Many a boy or girl remembers blissfully unoccupied summer days in his or her neighborhood. Those living near Vickroy Park had access to a staff of teenagers who taught crafts programs. Basket weaving was one option; the kits were inexpensive. Another option was painting ceramic items, like an anthropomorphic ceramic grouping of fruit: grapes, an apple and an orange, all leering at one another. When Wes Clark offered one such finished product to his mother to be displayed in the kitchen, she graciously found a rather hidden place for it.

A favorite parks occupation was creating items from gimp. Gimp creations nowadays are more popularly called boondoggles. It's those woven bits of vinyl lace, tied in consecutive knots so as to form a long chain. Kids could buy two lengths off a roll and begin knotting. These could be square or circular, depending upon the stitch chosen. The ends were always taken to one of the park counselors, who would melt the lace with a match so the thing wouldn't unravel. The business end featured a hook so as to hold keys or simply be attached to whatever and dangle. One fascination of these was in coming up with color combinations: blue and green, silver and gold, pink and light blue, light green and dark green and so on. By the end of the summer of 1965, Wes had a drawer full of gimp.

Burbanker Corey Fredrickson also has fond memories of the parks and rec programs:

Left: Ahhh…this is the life! Wes Clark Sr. enjoys a bit of sunbathing in the backyard pool on Lincoln Street, 1969. *Wes Clark*.

Below: Park League Basketball at Jordan Junior High, 1968. *Mike McDaniel*.

During the summers, all of the Burbank parks had programs every day of the week to keep us kids busy: contests, art classes like colored rock pictures on fiberboard, key chain weaving using colored lacing, making balsawood gliders with dope-laden wings, scavenger hunts around the neighborhood, caroms, chess, checkers, costume contests, basketball, Frisbee....Every day was themed and had a daily schedule....C'mon everyone, those were great times!

In the 1950s and 1960s, a nine-hole golf course sat near the intersection of Victory Boulevard and North Avon Street, where the Northwest Library and Ralph Foy Park are now. The golf course was owned by Mr. Arnold, who was the principal of Miller Elementary School. Mike McDaniel was playing golf with his father there once and hit a ball down the course. It freakishly hit a telephone wire square on; the wire flexed and sent the ball right back at Mike. There were also two miniature golf courses on Magnolia Boulevard where Burbankers played.

A decided advantage of the Burbank Water and Power Department doing major work on a street was the digging of large holes in the dirt. These became the dirt clod battlefields of Burbankers' youth, and many hours could be spent forming tactics and strategy with the neighborhood kids. Wes Clark remembers going to bed after one of these battles without benefit of a bath, and feeling sand with his feet under the sheets, he slumbered pretending that he was spending the night at the beach. Grownups always hated this and warned kids not to play at construction sites, with the usual admonitions about rusty nails and tetanus, but kids did it anyway. The smell of newly poured concrete and freshly cut pine two-by-fours is another happy childhood memory.

When the city built the storm drain system on Mike McDaniel's block, the crew created a trench on the even-numbered side of the street from Fifth to Sixth Street. The neighborhood kids played war in the "trenches," which contained an inexhaustible supply of dirt clod hand grenades. When the huge concrete pipes were installed, the kids would take their skateboards up to Sixth Street and enter the pipe, sit on the board and ride the pipe all the way to Fifth Street, where board and rider were shot out into the dirt. Great fun!

A favorite occupation of kids living near railroad tracks was placing pennies on the tracks and watching them get crushed by the great weight of the passing train. Burbank had plenty of industrial locations, and kids also enjoyed playing alongside the tracks: walking the rails, collecting

Above: Picnic at Mountain View Park. Check out the woman's bouffant hairstyle! *Mike McDaniel.*

Left: Summer program tug-of-war, Wildwood Canyon, 1970. *Mike McDaniel.*

discarded spikes and other railroad iron, throwing rocks at the passing boxcars, waving at the guy in the caboose and so forth. It was somewhat dangerous. Wes Clark remembers an instance when a train somehow advanced to within a block or two from him without his being aware of it. The engineer gave the horn a determined blow and scared a year or two off of the young man's life.

Another neighborhood attraction was the Lockheed Wash, a conduit for rainwater that ran parallel to the tracks. For literary-minded kids on a Tom Sawyer kick, the wash doubled as the Mighty Mississippi—albeit with graffiti on the concrete sides and broken bottles in the water. Once Wes (Huck) and his friend Richard (Tom) took burning newspapers as torches and explored the tunnel where the wash ran under Buena Vista Street. They were gratified to see daylight beckoning a few hundred feet away. Many a child spent time exploring the storm drains of Burbank.

The City of Burbank spent much money on erecting safer places for kids to play: the parks and pools (McCambridge had the biggest one) all had summer programs for kids. Kids could win ice cream eating contests held there. Mike McDaniel won one. When time was called, he had finished no less than *thirteen* scoops of Thrifty Chocolate Chip ice cream. The second-place eater had only finished eight scoops. OINK!

When parks and pools weren't an option, the local movie theaters were. In the 1960s, there were three in Burbank: the Magnolia, the Cornell and the California, all rather un-creatively named after the streets on which they were situated. The local drive-in theaters were the Pickwick and the San-Val.

The Lockheed Employees Recreation Club (LERC) provided fun programs, too. A local highlight was the annual gem show, held at what is now Robert Gross Park, named after a former Lockheed president.

For some, blissfully air-conditioned stores were the place to hang out. The Rexall drugstore on Lincoln Street wasn't a large place, but it had the things a nine-year-old needed: soda, candy, gum, ice cream bars, model cars and comic books. Boys would park their Sting-Rays by the back door and make the first right into the store, where the comics were kept in a spinner rack decorated with images of Superman, Archie and Sugar and Spice. (Comic book stores back then were unknown.) Many was the hour young boys would spend reading their stock and ignoring the growing numbness in their feet. Nobody in the store made any requirements that kids actually buy anything they read, and it was a delight to spend time on a hot day in this air-conditioned kid's lounge, escaping from problems and indulging superhero fantasies.

The mid-1970s Citizen's Band (CB) radio got its own distinctive Burbank twist when on Friday or Saturday nights the "Roadrunner" would take to the airwaves and indicate he was open for business. This meant that his vehicle was parked at Stough Park and he had booze for sale. The youth of Burbank whose cars or trucks were equipped with a CB radio could meet the Roadrunner, and the drinking would begin.

Like most communities, Burbank had a number of Boy Scout and Girl Scout organizations. One Scout activity involved learning to cook dandelions at a Buena Vista Park (now Johnny Carson Park) campout for a survival merit badge. The troop gathered them up from around the park and fried the leaves in butter. The taste was not impressive. One exciting nighttime game of capture the flag was ruined when the automatic sprinklers went on, drenching Scouts who were strategically hidden under a picnic table.

Left: Young library patrons, 1968. *Mike McDaniel.*

Below: A Burbank Boy Scout troop prepares to march in Burbank on Parade, probably 1950s. *Burbank Historical Society.*

Airway Bowling Alley, 1970s. *Burbank Historical Society.*

Scout activities always involve bathroom humor; males seem to be genetically hardwired for it. One particular hike in the snowy Angeles National Forest area involved the preparation of chocolate pudding, using hot water to reconstitute the food. The pudding came out runny, and the troop wit came up with the idea of pouring the pudding into the snow drifts to spell things such as "I have the runs!" and "trots." The humor became serious when another troop suffered intestinal problems from poorly prepared food, and during the night, Scouts were awakened by the sounds of running and painful moaning. The troop remembered the old schoolyard book title joke, "50 Yard Dash to the Outhouse by Willie Makeit, Illustrated by Betty Wont." Boys laughed in their tents for quite a while before going back to sleep.

Bowling was popular in the 1950s and 1960s, and there were four lanes in Burbank: Mar-lin-do, Pickwick, Airway and Burbank Bowl. Rifle sports were also popular; the shooting range at the McCambridge Rec Center was next to the pool entrance in the back parking lot. It was set up for .22 caliber pistols and target rifles. Shooters could go there to hone their skill or Scouts to pass requirements for the shooting merit badge. The Burbank High shooting team practiced there.

ADDITIONAL LEISURE ACTIVITIES

Cathy Coyle:

They had a Teen Age Fair at the Pickwick one year. We used to cram into telephone booths and even a Volkswagen Bug! And in the early 1960s, my sister and I used to go to The Pickwick Teenage Dance Party Show *filmed at Pickwick. We saw Shelly Fabares, Johnny Crawford and even talked to Bobby Vee! Never have we ever been so close to celebrities at a price of about $1.50 to get in.*

Margy Lillibridge:

Sometimes a studio would ask our school, Bell-Jeff, to send a bunch of students to fill the audience for television shows. We would get to skip a few classes, and I think the school was paid. I saw quite a few episodes of Donny and Marie, *and some game shows, too. Going to McDonalds was a big treat. We would park in back of the building against the fence. From there, we could look down into the Coke (or was it Pepsi?) plant loading dock. We were entertained watching the trucks come in, load, and pull out. Dinner AND a show!*

Corey Fredrickson:

Boys will be boys.…My brothers in the early 1960s did many things growing up in the flatlands of Burbank. We would go to the open fields next to Cricket Field on Riverside Drive with shoeboxes in hand to collect and watch "horny toads" spit blood from their eyes! This was an innate defense mechanism to scare off predators.…It didn't scare us! And living on Mariposa Street and Alameda Avenue, we had access to the livery stables at the very end of the street. My older brother and I would take a shortcut to Travel Town in Griffith Park. The shortcut involved walking through the enclosed bridge for horses that connected to the other side of the Los Angeles River. One thing you had to be cautious of was the tremendous amount of horse patties that lined the bottom of this bridge—sometimes this was close to a foot thick of digested hay. It was like a tunnel of methane gas…Pee-ewwww! We had to wash our P.F. Flyers off to get rid of the aroma! One particular day after making it to our destination at Travel Town, we played on the army tanks, air force jets and other relics.…Then we met the rock group the Association!

Judith Houver:

My friend Karen and I spent a lot of our Saturday afternoons at the California, Cornell or Magnolia theaters watching movies. In the summer we spent time at Karen's pool, dancing to Elvis with Burbank friends....As we grew older we spent Saturday nights at Olive Rec Center. We walked all over Burbank and never had to worry about our safety. It was truly an innocent time.

Peggy Melton Cyphers:

We rode our bicycles or walked. Burbank was really safe. As long as we were home before dark our parents didn't worry about us.

Tim Chamberlain:

We rode our bikes in the 1970s at a track above Bel Air Field called "Lucky Busters." [A BMX track behind the fire station near John Muir Junior High School.]

Rich Halliburton:

My grandmother lived on Evergreen Street, between Burbank Boulevard and Chandler Boulevard. "Engineer Bill" Stulla lived next door....He would let my twin sister and me hang out with him while he was working on stuff in his garage. He would let us play red light–green light with milk. Today, he would probably be in prison for all the fun we had. [Mike McDaniel was a guest host on the show one day; he got to yell "All Aboard!"]

Bob Marak:

Saw Alice Cooper at the Hollywood Bowl in the summer of 1972. The first chord from the song "Under My Wheels" shook the Bowl. At the end, a helicopter flew over the Bowl and dropped panties over the whole crowd. Those were the days!

Patti Steele Hallowes:

A lot of TP-ing of houses, as I recall. Only houses of people you liked!

Paul Watson:

Storm drain exploring was dark, fun and dangerous. We would enter at the basin at DeBell, and we carried flares we bought from Pep Boys for light. All sorts of junk was in there....Water would often be running down the tunnels from people watering their lawns or washing their cars. It was fun just to climb up a tunnel just to see where we were. Dead animals and debris littered the drains. These eventually emptied into the Los Angeles River. I once put my flare in a tunnel and ignited a pocket of methane gas. It singed my hair, and that was the end of my storm drain exploring.

Larry Levine:

Don't forget the Blue Crutch March of Dimes drive every year to raise funds for polio research and prevention. It started in Burbank and went national. Also, the annual March of Dimes dance and show at Olive Rec Center. Hank Riggio and Art Laboe would bring in the top talent of the day.

Jack Chavoor:

Verdugo Park all day: basketball or ping-pong upstairs, football on the field by the log cabin. They'd bring the trampoline out in the spring. Swimming in the summer. Ten cents for a box of popcorn, and fifteen cents for a box of Crackerjacks. The swing, the slide, caroms. And 1969 football practice at John Burroughs during smog alerts. The coaches would make fun of smog alerts and we followed their lead. Also, the Lincoln Elementary School Carnival with the exact same booths and activities from my brother's era (1949–56) to mine (1959–66).

Anita LeMaster Kranzberg:

Swimming lessons at JBHS and Verdugo pools; playing many years of Ponytail Girls' and Women's Softball; Campfire Girls; riding my bike all over Burbank; cruising Van Nuys Boulevard; hanging out at Bob's Big

Boy; playing Kick the Can and ping-pong with my brothers and friends; going to Verdugo Park for many of their summer craft projects and events; ice skating at Pickwick....I could go on and on.

Buena Joshi:

I swam at McCambridge. There was a polio outbreak at the pool in about 1952, and the pool was closed down. We all waited to see if we got polio...very scary.

Roger Lee Pickup:

Baseball games in the middle of the street after school until the street lights came on.

Nadine Aguirre Lujan:

I lived down the street from Valhalla Mortuary. We would ride our bikes through the cemetery and sneak into the egg dome, as we called it. When the door was ajar (probably workers) we would ride our bikes out of there like bats out of hell because dead people were going to come out!

Gregory Thompson:

Bicycle riding all over town as a kid in the 1960s and 1970s, going to the public swimming pools in the summer, sports and youth camps. I'm glad I grew up in Burbank during this time in history. The film and television industry was always fun and cool to be around.

Paul Hall:

We used to take the girls down into the Twilight Zone tunnels to scare them because we had to duck and hold each other as we walked through the tunnels. Even though I knew where I was going, I was very surprised when I tripped on a sleeping homeless guy. He jumped up and scared the hell out of me—which then scared everybody else. We all ran out of the tunnels. [The Twilight Zone was a wash tunnel near what is now called Johnny Carson Park.]

A scene in the Buena Vista Library, probably 1970s. *Burbank Historical Society.*

Patti Steele Hallowes:

> *Sliding down the hill on cardboard boxes…also putting on plays in the backyard, but this probably wasn't common for most.*

Kathleen Wyatt Richardson:

> *My family and neighbors played army in the mountains beyond our backyard!*

Tom Moriarity:

> *We did self-guided night tours at Universal Studios.*

Cartwheels Turn to Car Wheels

outhern California, cars. Cars, Southern California. The two things just go together. Was there ever a greater center for the car culture? Burbankers loved their cars as much as anyone, and there were plenty of speed shops in town.

When Joni Mitchell provided the phrase that serves as the title for this chapter in her song "The Circle Game," she referred to boys becoming drivers—sometimes reckless drivers.

Sometime in the 1970s, Rob Avery arrived at the idea of buying 100,000-candlepower airplane landing lights at James Auto on Magnolia Boulevard and using them to replace the anemic high beams in his 1973 Mazda truck. The idea caught on with his friends, and Mike McDaniel substituted the high beams in his 1969 Lincoln Continental. Thus armed, the pair were literally able to light up the town.

Most Burbank lads cruised Van Nuys Boulevard. Not the authors. They cruised the hillsides of upper Burbank, pretty much by themselves, usually in Mike McDaniel's Lincoln. One activity they particularly liked was to drive to the Mormon church building on Orange Grove Avenue and Sunset Canyon Drive. In the mid-1970s, that parking lot was one of Burbank's common make-out spots. A favorite game was to ambush lovers with the 100,000-candlepower airplane landing lights. This would normally irritate the driver to the point of a merry high-speed chase. Many a night have the authors known the terror and thrill of taking a 5,200-pound car through tight turns at high speeds on narrow residential streets, pursued by angry and frustrated fellow Burbankers.

Above: The Clark Fleet on Lincoln Street in 1978: Wes Clark Sr. poses with his '68 Porsche 912, Mike McDaniel poses with Wes Clark's '71 Porsche 914 and Mrs. Clark's '75 Cadillac Eldorado is on the driveway. *Wes Clark*.

Left: Fords hate Chevys, and Chevys hate Fords. It was always thus. Popular car-related art by Ed "Big Daddy" Roth, 1966. *Mike McDaniel*.

Former racecar driver Jack McAfee (*right*) is presumably receiving a check for that nice 356 Porsche in the foreground. *Burbank Historical Society.*

One wouldn't have thought it was possible to consummate a relationship in the rear of a Volkswagen Beetle, but a couple one night, in the glare of the Lincoln's light, displayed unusual athletic prowess—not to mention flexibility.

The standard escape procedure for losing underpowered cars (and there were a lot of them in the 1970s) was to get the Lincoln headed up toward the Verdugo Hills and stomp on the gas pedal, taking advantage of all 325 horses. This tactic used a lot of gas, but it lost pursuers in no time. At the top of the hill, the lights would be killed and the car would fade into the darkness.

Another evasive tactic, called "Avery's Alley" after its discoverer, Rob Avery, involved a high-speed entry onto Verdugo Avenue north of Sunset Canyon Drive. It looks like a dead-end street. In reality, a driveway to one of the residences at the end of the street passed the house and made a sharp left turn to connect to Tujunga Avenue. Often, the pursuer would simply stop and wait for the authors to realize their mistake. When they got to Tujunga they would shut off the lights and slip by unnoticed, confounding the pursuer. There were two of these on the hillsides, one in Burbank and another in Glendale. The Glendale one (no longer operative) had a nasty bump at the end that often had pursuers coming down hard and noisily on their oil pans; the sparks were always interesting to watch.

A feature of Mike's Lincoln was the fact that, with a quick swing of the steering wheel right and a swift recovery, one could launch the passenger side front hubcap at enemies in a straight line to the car's direction. Since the hubcaps were a heavy, premium trim style, this was a considerable threat to enemy pedestrians.

NOT THE *AUTOBAHN*

In 1978, Wes Clark bought himself a seven-year-old Porsche 914 from Jack McAfee Volkswagen-Porsche. The Poor Man's Porsche with a Volkswagen engine, it wasn't exactly fast but it *felt* fast, and mid-engined and rather wide as it was, it cornered like it was on rails. Late one night, he flew down the Burbank Boulevard bridge, took a hard right and zipped down Victory Place, gleeful at being able to gun it at better than eighty miles per hour through the deserted industrial section of town—only it wasn't deserted. One of Burbank's finest was on site and flipped on his

Wes Clark and his '71 Porsche 914, 1978. There is no autobahn in Burbank. *Wes Clark.*

red lights and siren. Wes, being a Marine at the time and obedient to authority, pulled over. The cop exited his cruiser, rubbed his face (leaving a smear with what looked like fingerprint powder), said, *"Zis is not ze Autobahn, Herr Porsche"* and issued a speeding ticket. At least he had a sense of humor.

THE SHOPPING BAG BET

The following story by an unnamed Burbanker is about a motorcycle and not a car, but the authors thought it too good not to include:

> *It's 1965, I'm finally eighteen and on my own sharing an apartment. I don't have much money. I owned a small Yamaha 80 motorcycle that my grandmother bought me for $400. One night on my Yamaha I saw my buddy. We pulled into the parking lot of the Shopping Bag Market*

on Glenoaks Boulevard and Irving Drive. My buddy bet me $25 that I couldn't drive through the store on my bike. Well…it was nighttime, not day, and it was only 100 feet, with not many people around, and it was closing time. The back door was open and the front would open when I hit the rubber mat. Easy money! I went in the back door, past the bakery and toy section, passing all the checkout registers. There were only a few people there and they got out of the way when they heard the Yamaha's wing-a-ding-ding and a shift into second. I slowed down, the front door opened automatically and then I did a left turn onto the sidewalk. Piece of cake! There's nobody after me and I'm rich! So I then drove to the parking lot to collect my loot. Just as my friend was going for his wallet an old man came out the back door, yelling. Time to leave! I start to exit when a policeman happens to come by, seeing the old man in an apron yelling and chasing me. The cop did some rapid detective work—which led to an appearance before the judge. I explained how I was broke and needed the money for rent. The judge assured me that I wouldn't need to pay rent for the next couple of months. I did 45 days, with 15 days off for good behavior at Wayside Jail with a bunch of criminals.

From the 1949 Burbank on Parade. Look at that gorgeous '48 Packard convertible! Our parents drove prettier cars than we did. *Burbank Historical Society.*

RIVER ROAD RACING, BY JAMES MCGILLIS

Friday nights in Burbank featured street racing on Forest Lawn Drive. That impromptu racecourse, also known as "The River Road," paralleled the path of the Los Angeles River. Launching from a hastily painted starting line, two cars could race side-by-side for a full quarter mile, where a second painted stripe marked the finish line. There, racers had to shut down and "clamp on the binders." Those with slow reactions or faulty brakes risked missing a sharp right-hander. At the time, the River Road was an isolated, rural location, yet it lay only minutes from the city. It took a while for the LAPD to discover that The Road had become an impromptu street-racing venue. Until then, a Friday night visit guaranteed seeing some racing action.

The fastest and most confident street racers would place their vehicles into an informal escrow. With their signed "pink slips" held by a neutral person, the winner of the race would return to the starting line and take title to the loser's car. In the 1960s, whenever we arrived at a stoplight next to a friend, the byword of the day was, "Hey, do you want to race for pinks?"

On one visit, my friends and I noticed the evidence that someone had missed the sharp turn. Leaving the road, that automobile had blown through the quaint wooden guardrail, and then sailed airborne to the brink of the LA River channel. Across the road from that shambles of a wreck, was the grand entrance to Forest Lawn Memorial Park. None of us was sure if the driver of that car made it out alive or became a permanent resident at Forest Lawn.

NO TWOFER

Burbank had more than its fair share of car nut kids. There were plenty of hot-rodded '57 Chevys, '32 coupes, early Mustangs, '56 Ford trucks and first-generation Camaros prowling the streets of town. These modified cars needed ways of testing their acceleration, and impromptu races were sometimes held on city streets. The police always tried to catch the perpetrators of these loud, and sometimes very dangerous, activities. Favorite locations included Glenoaks Boulevard in front of Burbank High School, Empire Boulevard south of the airport, San Fernando Boulevard north of the airport and the River Road racing described above. Getting caught was a no-good, very bad thing.

Star Lincoln-Mercury on 711 South San Fernando Boulevard, 1963. The building still stands, and you can still see the V8 glyph. *Burbank Historical Society*.

One day, a young Burbanker and two of his friends drove to one of the more popular racing venues in search of a rival hot rod to challenge. Such a rival was found, and the terms of the race were negotiated. The cars sped down the road in a manner best described by the lyrics of the Beach Boys "Shut Down" until a motorcycle policeman sped out from behind a tree in hot pursuit.

The driver slowed down for the policeman and pulled over to the curb. The rival continued on. The cop pulled up to the driver's side of the car, reached in and extracted the ignition key.

"You guys better not leave this car," he said.

"Okay, officer," said the driver. "We won't."

The motorcycle took off in hot pursuit of the fleeing rival. That cop wanted a twofer.

With the sound of the cop's Harley-Davison dying in the distance, the resourceful young Burbanker pulled out his wallet, extracted a spare key, started the car and made a U-turn before blasting back home. The policeman must not have written down the license plate because our hero was never apprehended.

MORE VEHICULAR MERRIMENT

Dianne Postal-Simmons:

> *We had a barbeque in a friend's van because we were stuck on the 101 freeway.... The guys would moon people!*

Jack Chavoor:

My friend Dale drove a 1967 Cougar in high school. Was "hood surfing" a thing? Because one day I was sitting on the hood of that car and Dale took off right down Lamer Street. And yes, there was another day when we got on the freeway at Buena Vista Street and I was on the hood at thirty-five miles per hour debating whether I would ever tell my grandchildren the story of the dumbest thing I ever did in my life.

Barry Burnett:

We used to play Bumper Tag with our 1940s and 1950s iron sleds. First car splits, second car counts to five, then chases. Five points for contact, three for a car length. When points scored, swap who leads and restart. First car to fifteen gets a Bob's malt from the loser. In alleys, we scored points for knocking trash cans over rear fences using only bumpers. My car was a 1948 Chevy Fleetline Aero Sedan. 16-gauge steel. No damage possible. Except to trash cans.

Sharon Smestad Burke:

My boyfriend (eventual husband) drove a 1960 Austin Healey; his best friend also had a Healey. The two of them would antagonize other drivers by either racing or driving slow, not letting anyone around them and driving on the right side shoulder when coming home from Zuma because of traffic. Two couples, young, fun… I don't regret a minute.

Viki Lynne Yonan:

I had my dad's '56 Chevy with my sister Jamie and Tim Wilson in the back seat. I was on Vanowen and Buena Vista Streets when the train guard came down on top of my hood. Little did I know I was too close! So I got scared and backed up, scratching the whole hood on his brand new perfect turquoise and white paint job. Jamie and I decided to try to clean off the scratch with Comet! Bad decision!

Jonathan Doe:

I had a friend who showed me how to raise the chain at the end of Walnut Avenue and drive under it to go up the fire roads to Brand. After a while

we would convoy with other cars. One time my friend was running a few minutes behind us so we waited at the first clearing. To our horror, BPD was waiting on the DeBell golf cart paths and at the lower Castaway parking lot. Here comes my friend in his Baja with a stinger and no baffle. BPD cut him off just as he made it to the chain. We must have driven up there a hundred times. Another time we were chased and the patrol car got stuck at the first hard left. Always late at night.

Tony Trotta:

I drove a 1943 military Jeep all through high school. One hot day while waiting for football practice to start, someone got the idea for everyone to climb onto my Jeep and I would drive around the block. I think I had a total of twenty-six people on the Jeep. I drove all the way around the school with the tires rubbing on the fenders because of the huge amount of weight. It was hard to see where I was going because people were hanging all over the Jeep.

Anita LeMaster Kranzberg:

I loved going to the drive-in at Bob's Big Boy in my parents' Pontiac Bonneville station wagon, and sitting in the rear-facing third seat with the window down enjoying a Big Boy hamburger, fries and shake with my brothers! We loved riding in that back seat!

Shari Boyd:

…seeing just how many people I could squeeze in my Mustang for beach trips. I really miss that car. Ten bucks filled it up. And speaking of fill-ups, let's not forget the odd/even days at the gas stations in the late 1970s—so much fun!

Mundo Bravo:

The huge drag racing scene across the bridge on the road out to Forest Lawn.…We had a quarter mile painted on the road. We'd all park on one side and light that strip up with our car headlights and race into the night. It was just across the Burbank line so the Burbank cops couldn't mess with us, and a long way for the LAPD to come. One night the L.A. cops blocked

Mike McDaniel in his Lincoln, out on the cruise. Check out those Jack in the Box prices! 1978. *Wes Clark.*

off both ends and arrested us all, like one hundred kids, for breaking curfew. Good times.

Rick Moran:

Pat Von Elm and I drove his 1940 pickup off of Barham Boulevard, where the Executive Condos are now, straight up the hill, almost a 60-degree climb, as far as we could go, then turned around, without rolling over, and went back down the hill. WOW.

Marie Martin:

My brother Bob used to run races with Volkswagens on our street (Shelton Street). He was an athlete. Fast. Quarterback. I think he won more often than not. Said he got a head start while they were shifting out of first. Is that possible, or is aging frying my brains?

Carol Nicholls Lebrecht:

I remember that you would put one of those orange Union 76 balls on your antenna so you could find your car in a crowded parking lot. Only thing

is that everyone else had the same idea and you would see a sea of orange antenna balls.

Mike King:

I once chirped the tires on my Cougar as I left the stop sign at Third Street and Burbank Boulevard in front of Motorcycle Officer Tack, who proceeded to give me my first traffic ticket for exhibition of speed.

Virginia Gockel:

On Tufts Avenue on the Fourth of July, we'd make homemade ice cream, with the old crank-style churn. The fireworks were just up the street in the hills at the dump. When it was time to watch the fireworks, we gathered every blanket we could and our ice cream, and headed for the top of the car, crawling up and grabbing a spot with my brother and sister. On the top of the car we lay. We sat and argued until the brilliant lights began, all calm and comfy with our ice cream. Oohs and ahhs overtook the arguing on the hot summer night.

Connie Barron Trimble:

My dad's 1963 four-door Ford Galaxy 500 XL held ten club members (YMCA Tri-High Y Rickshaws) on various jaunts around town: driver, front passenger and one on the console feet to front, one on console feet to back seat, four across the back seat and one each sitting where the feet went. Ten happy girls going to meetings, service projects, Bob's, car washes or TP-ing houses.

An evocative close to this chapter is the automotive part of the "You're Seriously Old San Fernando Valley If You…" Internet article:

Drag raced on Sheldon, Clybourn, Wentworth, the River Road or Forest Lawn Drive; Went to the Victory, San-Val, Sepulveda, Laurel, Van Nuys, Reseda or Pickwick Drive-In in the trunk of a car; Had a 45 rpm record player in your car; Ever bought gas at the Seaside on Sunland and Penrose or the Flying A on Sunland and San Fernando; Pitted at the San Fernando Drags; Owned a club plaque and jacket that said: Deacons, Pagans, Townsmen, Apollos, Khans, Lazy Gents, Road Runners, Throttlers,

A hard-to-miss sight on the Burbank streets was Ernie Steingold's 1975 GMC California Fantasy Panel Van. Steingold, a vacuum cleaner repairman and, apparently, a fitness advocate, lived on Wyoming Street. The van can be seen in the opening credits of Steve Martin's *L.A. Story*. *Photo copyright Harrod Blank (artcaragency.com), used with permission.*

Chancellors, Street Racers, Igniters, Poor Boys, Lobos, Lost Angels, Night Owls, Drifters, Innocents, Lynchmen, Nomads, Uhlans, Majestics, Diablos, Sultans, Strokers, Titans, Turks, Saints, Night Walkers, Road Huggers, Road Dusters, Rebels, Sidewinders, Midnighters, Prowlers, Road Kings or Jokers; Went to Blackies or Cooper and Suds looking for auto parts; Bought auto parts at Rounds or The Chrome House; Bought primer or Bondo at Standard Brands; Had hubcaps called lancers, spinners or moons; Got your car lowered at Smokey Cohea's Muffler Shop; Raced on the Golden State or 210 freeways before they were opened; Cruised Bob's in Glendale, Toluca Lake, Van Nuys or San Fernando; Cruised Van Nuys or Hollywood Boulevards.

10

Hooligans

Hooliganism is as old as mankind. Neanderthal males, if they managed to live long enough to attain the teen years, almost certainly placed pinecones on logs or rocks as their friends attempted to sit. Pirates, of course, rubbed whale grease on the inside of a mate's eye patch, giving the victim a black eye.

The proper age for a hooligan appears to fall somewhere between puberty and adulthood. While that is a fairly wide range of years, clearly, the fat part of the bell curve overlaps high school. The rivalry between the two Burbank public high schools, Burbank Senior High School (Bulldogs) and John Burroughs Senior High School (Indians), was supreme, but not violent. The rivalry-related hooliganism of Boomer days rarely ventured beyond drive-by shouting.

The authors of this book were Bulldogs during the early 1970s; a contributor had two older brothers who were Bulldogs during the early 1960s. Their exploits are described below. With some exceptions, the acts of hooliganism depicted herein occurred within the Burbank city limits. The names have been changed to protect the reputations of those living and dead who, certainly, spent their adult years growing out of their desires for mischief.

DRIVE-BY SHOUTING

The reference to drive-by shouting was not meant to be just a play on words in contrast to the horrific drive-by shootings we hear about on today's nightly news. It's literal—young Burbankers really did a lot of shouting from moving vehicles.

Every year, the Burbank-Burroughs football game ("The Big Game") and the week preceding were filled with intense rivalry. Burroughs students would drive past Burbank High and shout at its students. Finger salutes might be exchanged, and rarely, eggs or water balloons might be thrown. Similar attacks were launched against the Burroughs students.

One day, a BHS Bulldog discovered that a guy could buy a simple transistorized amplifier from Electronic City for five bucks, mount it to the wooden lid of a discarded Old Spice box with some Bondo and hook up a spare microphone and loudspeaker (mounted under the hood) to achieve a weapons-grade drive-by shouting capability. Eventually this caught on.

Left to right: John Z., Mike Kurthy and Marty Scott work on a Pontiac Bonneville on Parish Place, 1977. John Z. demonstrates 1970s-style digital messaging. *Mike Kurthy*.

These devices were used with much glee to annoy friends (and others) on the street. A guy could drive up next to a couple kissing in a car and make rude heavy breathing sounds or try to imitate a police siren. It was all in good fun; all about achieving maximum comic effect. There was the nagging sense that all of this good fun could actually be against local codes and ordinances, so we were discreet in our public address usage. In this sense, discreet meant looking around to verify the absence of a local cop before activating the system. This bit of caution paid off. We were never caught.

A Notable Egging

One school day in the early 1970s on Glenoaks Boulevard, in front of the Burbank High print shop, a camper drove by to taunt BHS students walking on the sidewalk; every now and then a Burroughs student would fling an egg at a pedestrian from the back door of the camper while hanging on to a hand rail, then pop back inside the camper and slam the door. On one pass, the camper got stuck at a red light, and a car with four vengeful BHS boys pulled up behind. They jumped out of the car, each holding a carton of eggs, opened the back door of the camper, and opened fire. Many of the eggs went all the way through the cab of the truck and smacked onto the windshield, a gooey mess. The moral of the story? If on an egg run on a rival school's turf, always lock your camper door!

The Quag

You have undoubtedly seen the Los Angeles River in any number of movies. Built for the short-lived seasonal floods, the river is nearly dry for much of the year. Those long and dry stretches of concrete were often used for chase scenes, gang fights and car races, in dozens of movies. Everything from 1950s horror movies (*Them!*, 1954) to singing and dancing car races (*Grease*, 1978) to a three-vehicle, science-fiction chase scene (*Terminator 2: Judgment Day*, 1991) was filmed in the Los Angeles River.

The river is fed by a system of large storm drains and tunnels. Because they carry the huge quantities of water that drain across the San Fernando Valley, these tunnels are necessarily large. One can easily drive a commercial delivery van into the tunnels with room to spare. Proof of this capacity can be readily seen in *Them!* A large portion of the movie depicts numerous

The scum-green Quag of the Los Angeles River near Burbank, site of much vehicular merriment. *Mike McDaniel.*

army vehicles driving in the tunnels followed by troops equipped with flamethrowers, all ready to do battle against giant mutant ants who have annoyingly colonized the storm drain system.

The bottoms of the tunnels always have at least a small amount of water flowing through them, and the bottom is mossy and littered with the detritus that runs off the city streets. This quality lent itself to being called "The Quagmire" or, in more common parlance, "The Quag." Numerous adventures took place in the Quag. Daring youth would crawl into a Burbank storm drain with a Flexi Flyer (think of a sled with wheels but no brakes) and ride miles through the Quag all the way to the river. It was a fun and daring feat that covered the rider with muck and slime.

Working from the other direction, it was easy to drive one's car from the river into the farthest reaches of underground Burbank. One day, a group of fellows pitched in to buy a fairly beaten 1950s Mercury to drive in the Quag. It did not take long to reach the usual place where no fence or gate barred their entry. Driving down the angled bank to the concrete bottom, they turned left, drove a few hundred yards, and entered the main tunnel

leading to the Burbank storm drains. Sunlight faded as they drove deeper, so the driver turned on the headlights. Dank concrete walls stretched up ahead as they drove through a tube a dozen feet across. They had a marvelous time underground and drove several miles before they realized that the Mercury's gas gauge always registered at half a tank. They ran out of gas.

No, they were not going to walk out of there—miles of nasty hiking in a mossy, dark tunnel. They found a nearby storm drain that led to a street above ground and crawled out into the daylight. They made their way back to the garage where they hung out and made their plan to retrieve the old Mercury. But some of the guys had to go to work, and the other guys had dates that evening. They postponed the retrieval operation until the next morning.

One day turned into two.

Burbanker Corey Fredrickson, looking like a young Harrison Ford, poses with his 1969 GT350 Shelby Mustang, 1973. Black Jade with white interior, racing seat belts (cross over chest), Hurst 4 speed—a very rare option car. *Corey Fredrickson.*

As they were finally getting ready to rescue the car, a friend drove by with a girl. They told the friend of their plan to retrieve the car. He wanted to go.

"Gimme a minute to drop her off, and I'll come with you guys," said the friend.

"No," said the girl. "I want to go, too."

There were no objections, so the six of them jumped into a van owned by one of the guys and headed toward the Quag to find the car. They had the forethought to bring a couple gallons of gas. When they got there, however, they found that somebody had stolen the car's battery, slashed all four tires, torn up the interior and smashed the windshield. Who would have thought that there could be that much traffic in the Quag over two days?

So, what were these young folks to do with that two extra gallons of gas? Of course! They poured it all over the back seat and tossed in a lit match. They hastily drove out of the Quag and into town. Curiosity possessed them, so they made their way to the intersection where they had made their escape a few days earlier. They arrived to find a number of police and fire vehicles milling about, the first responders wondering why smoke would be billowing out of the city's storm drains.

Stough Park Shenanigans

The Starlight Bowl was built in 1950 in the eastern hills of Burbank, well above the valley floor. The dirt parking lot was large and stretched all the way from the bowl to a steep mountain dropoff. You could lay almost three full football fields end-to-end against that perilous edge. And that edge offered a fine nighttime view of the San Fernando Valley to the west. It became a popular place to take a date, park overlooking the valley and watch the sun set. A lot of those cars stayed later to view the city lights. Sometimes the view was hampered by fogged car windows. It didn't seem to matter all that much, though, and in those carefree days, the police never seemed to pay much attention.

The slope of the hill was steep and barren of any structures until it met Bel Aire Drive, a third of a mile to the southeast and 450 feet down from the parking lot. There was only one building on the east side of Bel Aire, a Burbank fire station. Local hooligans would sometimes dispose of old tires by taking them to the parking lot during the day when nobody was there and rolling them down the hill. They would bounce a little and gain speed but would soon fall over and disappear into a canyon a few hundred yards

Corey Fredrickson's 1970 Boss 302 Mustang, 1975. Grabber Orange, black louvres, Hurst 4 speed, posi-traction rear end, shaker hood scoop. *Corey Fredrickson.*

down the hill. One fellow brought an old wheel he no longer needed on one of these disposal runs. The tire was bald but still held air. He rolled it down the hill expecting the same result as the rest of the old tires, but the group was surprised. Pumped with air and aided by the mass of the steel wheel, the tire rolled with greater purpose. It, too, disappeared down the same canyon but, a second later, shot away from the mountain and careened, airborne, toward the fire station.

One of the boys expressed some concern that the wheel and tire might fly off into one of the houses on the west side of Bel Aire Drive, but all they could do was watch as horrified onlookers. The wheel, however, began to wobble mid-flight and then landed flat side down on the roof of the fire station. One can only imagine the sound made inside the building when that forty-pound wheel smashed against the roof. Observers from the parking lot noted that firemen ran out of the doors of that station like ants escaping their nest to attack marauders. The boys rushed to their cars and drove home.

Above: Burbanker George Marciniw poses with his 1956 Chevy, 1972. He may look like a hooligan, but he wasn't. (Most of the time.)
George Marciniw.

Right: George Marciniw poses on his driveway on Bel Aire Drive with his 1934 Ford five window coupe, 1974.
George Marciniw.

Other hooligans would wait until the cover of darkness to carry out their mischief. As stated before, the edge of this huge parking lot was a popular place to, ahem, "park." Cars typically contained a male driver and a female passenger. Hooligans would drive behind the line of parked cars until they identified a high school chum's vehicle. They would stop behind it, and a passenger would get out, pound on the driver's side door of the other car, and yell something akin to *"That's my sister in there!"*

The pounding would only last for a few seconds, just long enough to shatter whatever romantic mood may have existed in the victim's car. The window-pounding hooligan would then run back to the waiting getaway car, and the group would drive off in a burst of speed and a cloud of dust, screaming in paroxysms of laughter. The reader might think this was cruel, but one wonders how many unwanted pregnancies were avoided by the acts of these hooligans.

Tormenting Teacher X

The following story, author's name withheld, is offered on good authority from the memories of several individuals involved. That having been said, youthful adventures are sometimes affected by age. Fertilized and watered over the years through the telling, they may tend to grow a bit. Knowing the personalities involved, however, the authors believe every word:

> *Burbank High School's Class of 1963 included a number of strong and interesting personalities. Some of them were in Teacher X's class, and they were total goof-offs. Teacher X was not pleased with them.*
>
> *Teacher X's wife started getting crank phone calls of a somewhat pornographic nature and Teacher X suspected one of these goof-offs.* [This was in the days of rotary phones and no caller ID.] *One Saturday afternoon, while Teacher X's wife was receiving such a call, Teacher X ran to a neighbor's house and dialed the suspect's telephone number. The line was busy. Considering this to be case-hardened evidence of malfeasance, Teacher X jumped to the erroneous conclusion that this was the perpetrator.* [The fellow in question had a perfect alibi, as he and the rest of the crew were in Santa Barbara at a car race.] *An angry Teacher X set forth to exact his vengeance.*
>
> *Teacher X called the friend's mother to report this evil behavior, but she did not believe him. In fact, she protested that she had been on the phone*

at the time he had tried to call. Teacher X accused her of covering up for her son. Words were exchanged, and Teacher X reportedly elevated it to an excessive and insulting level. This, of course, meant war, and the crew stepped up to it.

It started small when the first of several unordered pizzas was delivered to Teacher X's home. Eventually, every pizza delivery place in our fair city [there weren't many; delivered pizza was not all that common in the early 1960s] *learned to avoid Teacher X's address. And every Chicken Delight franchise* [much more common at the time] *learned as well.* ["Don't cook tonight! Get Chicken Delight!"]

A member of the gang ordered a flamingo-pink Sears folding boat to be delivered COD. A confused Teacher X had to wave off the delivery guy. Next, an ad was placed in the Los Angeles Times *classifieds for a 1932 Ford roadster—a highly desirable car, at the time—at an unbelievably cheap price. The ad included the words "Day sleeper. Call between 2 am and 4 am only." The ad ran for three weeks, and Teacher X got no sleep. A similar ad for a Woodie wagon—the Holy Grail of surf wagons—ran in the* Herald-Examiner *for two weeks, but it listed no phone number, only Teacher X's home address. Hundreds of people showed up to buy the fictitious car.*

Then one of the group, a fellow who worked part-time for ConRock, arranged for a dump truck to make a very early morning delivery of several cubic yards of gravel onto Teacher X's driveway. On a school day. Teacher X's car was trapped and he had to walk to school. That very afternoon, as Teacher X was walking home from school, two of the group drove by. One brave fellow rolled down the window and asked if "...that '32 roadster was still for sale." Teacher X flipped, picked up a rock and threw it, hitting the car.

They drove to a house where an old-style fire extinguisher could be found. They urinated into it and then filled it up with orange juice, motor oil and water. They added compressed air and set off to find Teacher X. He was almost home when they pulled up. A smart-aleck remark was made, and as Teacher X lifted another rock, the fire extinguisher's awful brew was emptied upon him. Teacher X snapped. His car still stuck behind a mountain of gravel, he chose to run to the police station.

The group dropped off the empty extinguisher, eliminated as much evidence as they could, and drove to the police station themselves, beating Teacher X by only minutes. They ran into the police station and explained that there was a crazy unkempt man who was throwing rocks at cars.

Female hooligans TP-ed Mike McDaniel's house on Elmwood Avenue, 1978. *Mike McDaniel.*

Teacher X ran in as they explained the details to the desk sergeant. They screamed "That's the guy!" and Teacher X flipped again. He rushed them and was, eventually, restrained by several police officers. During the melee, Teacher X kicked a cop. Legend has it that he was tossed into the drunk tank for an overnight stay. Nobody is absolutely certain if that's true, but one can appreciate the visual image of Teacher X, clad in a urine- and oil-stained suit, exchanging pleasantries all night with some of Burbank's finer drunks.

Eventually it was all sorted out. Teacher X dropped his charges against the gang for the fire extinguisher attack, and they dropped theirs against Teacher X for the thrown rock and dented fender. All parties were certainly reprimanded by school authorities and parents.

As for the authors, they have fine memories of Teacher X and are convinced that whatever they were paying teachers in those days, it wasn't nearly enough.

Cattle Rustling at the Jessup Dairy

In 1919, Roger Jessup started a dairy in neighboring Glendale. Over time, the family opened numerous drive-through, street-corner kiosks from which they sold their dairy products. There were several of these in Burbank. Each of the little stores featured a full-scale plastic replica of a Holstein dairy cow. Sometimes, the cow was near the corner where drivers could easily see it, and sometimes the cow was bolted to the roof of the store, lowing over all it surveyed.

One day, the *Burbank Daily Review* ran an editorial written by the Burbank police chief. In it, the chief complained about an increase in local vandalism and how this type of behavior was both unnecessary and un-American. The next day, somebody stole the plastic dairy cow from the front of one of the Jessup Dairy stores and placed it on the well-intentioned police chief's front lawn. A note was left by the perpetrators: "Do you still hang people for cattle rustling?"

A Miscarriage of Justice

A youthful Burbanker recounts a gross miscarriage of justice, as follows:

> *It snowed pretty heavily up in the Verdugo Hills one winter day so we drove up there to get a bunch of snow. As we were driving back to high school, I spotted a police car and decided to give it a shot. I packed a snowball and threw it. The policeman's window was down and the snowball hit him right in the side of his face. It was a one in a million shot but it wasn't very lucky. I got a ticket for "throwing a destructive missile across a thoroughfare" and lost my driver's license for thirty days. I wasn't even driving at the time. How was yanking my license justice?*

Disclaimer

The activities in this chapter are depicted solely for the sake of humor. If any of them draw a giggle from the reader, then the authors smile approvingly. However, being older and more responsible men, the authors do not encourage or condone vandalism or any other types of dangerous and/or criminal activity. Times have changed. Being caught by the police no longer

results in an ad-hoc lecture and a call to your parents so they can "straighten you out" with a simple beating. You are more likely to meet an aggressive and ambitious prosecutor who thinks in terms of "years in prison" rather than "days in jail." The fine? You cannot afford it.

Enjoy these stories from yesteryear, but please, do not attempt to make them your own.

11

Working Stiffs

I t just might be that the first work a kid did to make some candy money was to patrol the city's numerous vacant lots searching for discarded but intact glass bottles to return to stores. The 1966 rates were such that the larger bottles were worth a nickel, the smaller ones two cents. (The pre-metric sizes were that the larger bottles were about 32 fluid ounces and the classic Coke bottle was only 6.5 fluid ounces.)

From Lockheed to "Laugh In" Burbank's glamour industries

Dan Rowan (*left*) and Dick Martin, 1970. *Mike McDaniel.*

When one considered that a candy bar back then was a nickel or a dime, and a Hostess fruit pie was twelve or fifteen cents, the bottle harvesting obviously rewarded the diligent. What's more, it also cleaned up the neighborhoods. Given this and remembering how much better Coca-Cola with real sugar tasted in ice-cold glass bottles, why aren't we recycling glass bottles anymore?

Employment for the young in Burbank was like entry-level work anywhere else. Almost always, a kid's first job was as a paper boy, and the going newspaper concerns in Burbank were the *Los Angeles Herald-Examiner*, the *Daily Review* and the fondly remembered *Valley Green Sheet*. (It was so green even the rubber bands holding the papers together

were green!) Later on, a kid could be a grocery line bagger (back in the sexist 1960s and 1970s they were called "box boys") or work at a restaurant as a water boy (even more sexist).

THE RECORD BUSINESS

The record group giant in the 1970s was Warner-Elektra-Atlantic (WEA) as well as Warner's Reprise Records—these were headquartered in Burbank. A list of their hit records in the 1960s and 1970s would comprise a who's who of rock and pop. Printing the album material for these companies was subcontracted out to various firms, some in town.

Burbank's United Sound and Graphics could record, press records and then print the record labels and sleeves. It printed the center labels for the popular Warner Bros. records. The company also made "loss leader" record sleeves for Warner, including two-record compilation sets featuring many Warner artists. (One album might have several songs from Alice Cooper, James Taylor, America, the Doobie Brothers, Fleetwood Mac, Deep Purple, Jethro Tull and so forth.) A notable loss leader release was *Burbank*, which featured a tooled metal logo in the style of a recent well-known Chicago album. Another Warner Bros. loss leader collection was *The Whole Burbank Catalog*, which riffed off of *The Whole Earth Catalog*. United Sound and Graphics also produced small groups of record albums for local school bands, church and school choirs, city musical ensembles and local orchestras, as well as rock bands wanting to create a demo. The record material was printed and packaged in the plant located behind the Bob's Big Boy on Glenoaks Boulevard near the Villa Cabrini development.

The liner notes to the *Burbank* loss leader set, written in 1972 by Barry Hansen, provides an interesting snapshot of the times:

> *When discussing a small town of any size, one commonly begins with lines like "Middleburg is a microcosm of the whole U.S.A." Burbank, a middle-sized town, fits that description passably with its neat homes, churches and hospitals, plus a dandy downtown. But considering how the whole U.S.A. is daily saturated with fantasies, fancies and other images manufactured in this suburb on the sunny side of the Hollywood Hills, it would be far apter to say "the whole U.S.A. is a macrocosm of Burbank."*
>
> *Yes, Burbank boasts the studios of a well-known TV network, plus those of a famous purveyor of exclusively G-rated entertainment of various*

Burbank, a Warner Bros. loss leader record, 1972. *Mike McDaniel.*

varieties. But way over on the west side of Burbank, even further west than the home of Bonanza or that of Mickey Mouse, is that mighty manufacturer of movies and melodies affectionately known (thanks to its bright yellow water tower) as The Burbank Studios. Within this bubbling beehive of activity may be found the solar plexi of several divisions of Warner Communications, Inc. Right in the middle of the honeycomb, at 3701 Warner Blvd., to be exact, is a two-story building, a bit drab on the outside but most colorful on the inside. Within it are colonies of happy workers battling against the forces of doom, doubt and deadlines to enrich America and the world of music. This is Warner Bros. and Reprise Records (and tapes)….It's a fun place to make records, that ol' Burbank!

LOCKHEED TALES

How many Burbankers either worked for Lockheed or worked for a company that contracted to Lockheed? Or possibly worked for a company that worked for a company that worked for Lockheed? That's how big a presence this major aerospace employer had in the city. No Burbanker, attempting to drive anywhere in the city at the hours when the plants on Hollywood Way and Empire Avenue disgorged employees during shift changes, could fail to be aware of the Lockheed Aircraft Company.

THE HATED WILLIAM PROXMIRE

He was only a senator from Wisconsin, but, due to his efforts to thwart a government bailout of Lockheed, he quickly became *persona non grata* in Burbank when jobs were on the line. It was 1971, and Lockheed was headed toward bankruptcy, due, in large part, to the bankruptcy of Rolls-Royce Ltd., which manufactured the jet engines for the L-1011 passenger jet. Lockheed management was seeking a loan to keep the company afloat. Senator Proxmire was seeking to bury Lockheed alongside the Supersonic Transport (SST).

A boycott of cheese and other products from Wisconsin was organized, and Lockheed families were encouraged to write to Congress expressing their support for the bailout loan. The first political letter of Wes Clark's life was written to Senator Proxmire's office over this issue. Instead of including a return address, he drew a picture of an L-1011 dropping bombs on an outline of the state of Wisconsin.

When Wes Clark worked at Lockheed in 1979, he was once given the assignment to clean the interior of some large ductwork that extended over a section of the plant called Pneumonia Alley (so called because of the bone-chilling drafts that blew through the place during the winter). He has never forgotten this job. Being twenty-three, agile and low on the totem pole, he was the stuckee for this mission, which required him to fit into a metal space approximately three feet square and to crawl along its length, all the while swiping the interior tops, sides and bottom with a rag. The length of the ductwork was perhaps 150 feet. He fortunately didn't suffer from claustrophobia.

What his management didn't tell him, however, was that hot air normally flowed through this ductwork. Whatever it was that produced the hot air was shut down, but the ductwork hadn't cooled thoroughly and Wes found things getting quite warm about mid-crawl. It felt like the air in the long middle section of the duct was over one hundred degrees, a tunnel through hell. By the time Wes emerged on the other side an hour later, he was sopping wet with sweat and spent the next few minutes gulping down large amounts of water and recovering. So it is a curious fact that Wes Clark's most vivid memory of a place called Pneumonia Alley is of suffering from too much heat.

A memorable Lockheed maintenance job occurred after somebody phoned in a bomb threat, and Lockheed management sensibly had the interiors of the buildings cleared. The Burbank Police arrived with Fire

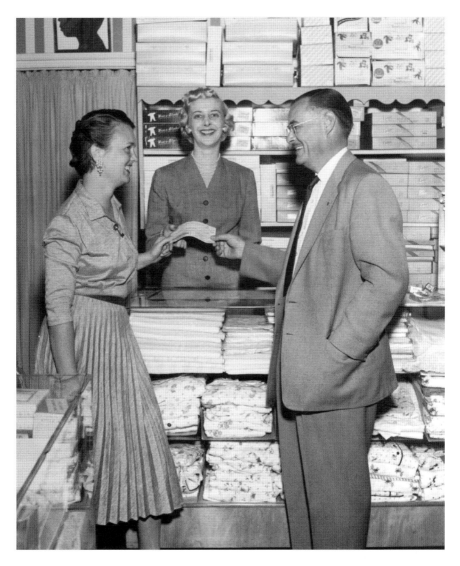

Both women are grabbing for it, but only one will get that check, late 1950s/early 1960s.
Burbank Historical Society.

Department pumper trucks and more. Quite a scene. The maintenance staff were assigned to go from office to office emptying trash cans. Why? They were looking for a bomb, of course. The makeshift explosive ordinance disposal work continued until the labor union stewards got wind of it and angrily voiced their objections to management, threatening grievances. The maintenance staff were soon told to cease and desist.

OTHER BURBANK BOOMER JOBS

Burbankers on the "You Know You're from Burbank If…" Facebook group provide descriptions of various jobs in town for Baby Boomers:

Paul Bittick:

> *I went from being a paper boy in the 1960s to the sports editor at the* Burbank Daily Review *in the late 1970s.*

Pam Kirkwood:

> *I worked at Dotty Lee's Dress Shop on the corner of San Fernando Boulevard and Palm Avenue…and worked for the Burbank YMCA as a "Summer Fun Club" counselor.*

Les Heller:

> *One of my very first* real *jobs was washing dishes at Kings Chop Suey near Bill's Ranch Market. The kitchen was run by the grandparents. The old man's instructions were "Make the water as hot as you can stand—* then a little hotter!*" When done, after they had closed, he sat me down and said "Now you eat." I told him I wasn't hungry; his reply was "*You eat!*" So of course, I asked for Chinese spare ribs.… Theirs were some of the best in town!*

Marie Martin:

> *My first job was at Valley Rubber Stamp on Magnolia Boulevard near my house on Shelton Street, circa 1964. This was before I even had a proper work permit. I learned so much! Patient teachers, they taught me responsibility, genuine customer service and how to get an order filled from start to finish. Just plain old work, every day, day after day. They taught, without ever mentioning it, the rewards were not about tons of money but about commitment, honesty and showing up. Great stuff for a fourteen-year-old. I will always thank them. I hope somewhere, kids are still getting this kind of guidance.*

Lou Schutte:

My favorite job was at Burbank High as head cook at the ripe old age of twenty-six! I loved the ladies I worked with; they were much older than I and so much fun. I remember when I applied, they gave me I.Q. tests. When we got the results, a bunch of administration folks came out to meet me. I guess they wanted to see the girl who was looking for a job washing dishes who scored 142 on the test. I was surprised, too!

Rick Watts:

My dad was a chef at the Kings Arms restaurant in the early 1970s, and I had to go to work with him after school because my mother also worked at the time. One night, I was standing out by the front door and started opening it for people. Well, they started tipping me. I had close to $100 after a couple of hours! I showed it to my Dad, and he made me give half to the valet and told me to never do that again.

Mike Arredondo:

I worked at The Akron! It was my first job, ever. We stacked the shelves. Nothing very memorable, but one Saturday they had me move a pallet of goods down the aisle. The aisle wasn't wide enough to fit through; needless to say there was a display of champagne glasses stacked pretty high. All it took was a slight bump. Yes, in slow motion (in my mind), they came tumbling down.

Ronna Payne:

I handed out carnations at Bill's Ranch Market on Mother's Day, 1959. I was thirteen and had to get a Social Security card for the one-day job. I don't remember what the paycheck was.

Patrick Thompson:

I worked at Lil' Abner's Liquor Store from 1968 to 1972; it was located at Screenland Drive and Burbank Boulevard. It was a great place owned by some special guys, the Oliva Brothers—Johnny, Mike and Key. Those guys sure showed a young kid what life was all about. One of their

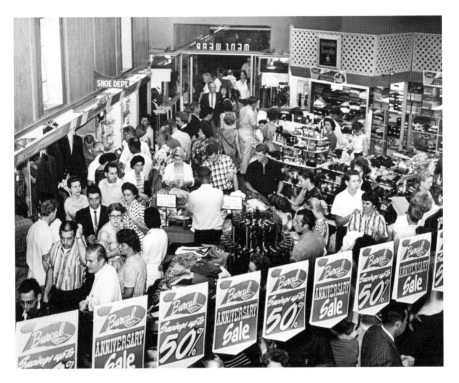

Big sale at Bur-Cal, 1960s. *Burbank Historical Society.*

major accounts was the Gunsmoke *TV show. At the end of every week, the cast and crew would have a big party, which wrapped up that week's show. I once parked my delivery car in front of the Long Branch Saloon and proceeded to unload it, past the famous double saloon doors, and placed all the cases on the bar. I scanned the various bottles and nonchalantly said, "Man, that sure looks good!" I was nineteen years old and never had a drop of hard liquor in my life, but the head grip said to me, "Kid, you want a drink?" In my mind I saw all the cowboys taking shots at the Long Branch bar, and said, "Sure!" He then proceeded to pour whiskey into a small styrofoam cup and filled it half way, and asked, "7-Up?" I said, "No." He asked, "Water?" I said, "No." Some guy behind the bar says, "Give the kid some ice," to which I said, "No, thanks." I then put my foot on the rail at the base of the bar, leaned onto the bar and, remembering those cowboys, gulped the whiskey down in one move. I looked at the head grip and said, clear as a bird, "Thanks!" I then turned around and walked out of the Long Branch, opening those*

double doors with both hands. As I exited, the head grip said, "Man, they raised that kid right!"

By the time I got to the car my throat was on fire, my eyes were watering and I was wondering why I had done what I just did. I had to pull over to the side of the road on my way back to work!

Media and the Media City

When it comes to movies and television, Burbankers are a remarkably blasé bunch. That's because so many of them work in the industry or are simply just used to seeing film shoots taking place around town. They're not easily starstruck.

An Internet Movie Database search for titles with the word "burbank" in the search box for "filming location" turns up no fewer than 20,168 titles, the majority no doubt attributable to locations at Warner Bros. and Disney Studios. An IMDb search for the search term "burbank" appearing in "biographies" turns up no fewer than 638 names. Finally, there are 78 titles with "burbank" in the plot. That's how big Burbank was, and is, in the entertainment industry.

In the Boomer era, Burbank even had its own radio station: KROQ ("The ROQs of L.A.: Mother Rock!"), born in 1972 when KBBQ (country format) went off the air. Transmitting from the Verdugo Hills, the lineup of disc jockeys included Charlie Tuna, Sam Riddle and Shadoe Stevens. But it didn't last long. In 1974, financial problems caused the station to shut down. It returned later in the 1970s in Los Angeles.

It's always fun seeing Burbank locations appear in movie and television productions, but a lot of the time, action was filmed in town without any visual location clues because shooting was backstage or on sets. In the Baby Boomer era, the following television productions were filmed at Columbia Ranch along Hollywood Way: *Father Knows Best, The Donna Reed Show, Dennis the Menace, Hazel, Bewitched, Gidget, I Dream of Jeannie, The Monkees, The Flying*

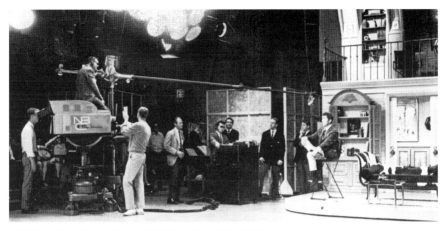

Above: Taping *The Dean Martin Show* at NBC Studios, 1970. *Mike McDaniel*.

Left: Filming the 1962 movie *13 West Street* in early 1961 on Lima Street. It starred Rod Steiger and Alan Ladd. *Rose Caven Piazza*.

Nun, Here Come the Brides and *The Partridge Family.* Wes Clark remembers that the Partridge family bus, with its unique paint job, was usually parked at a gas station on San Fernando Boulevard.

Perhaps the most perfect intersection between Burbank reality and a media depiction of growing up as a Baby Boomer was the ABC television show *The Wonder Years*, which ran from 1988 to 1993. Not only was the depicted Arnold family home actually located in Burbank (516 North University Avenue), but also the protagonist, Kevin Arnold (played by Fred Savage), was described as being sixteen in 1972, which means that he was born in the same year as the authors and experienced the 1960s and 1970s at the same ages they did. What's more, the production company

A break from filming *13 West Street*. *Left to right*: Paul Caven (in St. Finbar school uniform), unknown girl, Alan Ladd, cousins Christine Caven Sardino and Rose Caven Piazza. *Rose Caven Piazza*.

used John Muir Junior High School, which Mike McDaniel attended, for filming—remarkably, Kevin's locker is just five feet away from Mike's. The only way it could be a closer match was if they had filmed at Burbank High School, but no, they did the outdoor high school shots at Burroughs. Still, it's uncanny. Burbanker Raymond Christopher noted, "I got expelled from John Burroughs High School for yelling at the cast from *The Wonder Years*; they used to film scenes in the cafeteria."

Another great thing about growing up in the Baby Boomer era was local television broadcasting—now, excepting cable access, apparently a thing of the past. Burbankers enjoyed the many before and after school kid's shows broadcast from Los Angeles, only eleven miles away: *Hobo Kelly*, *Sheriff John*, *The Pancake Man*, *Chuck Jones the Magic Man*, *Popeye and Friends* with Tom Hatten, *Cartoon Express* with Engineer Bill (a Burbank resident), *Winchell-Mahoney Time*, *Chucko the Clown* and the *Bozo the Clown* show. A very young Wes Clark attended a taping of the *Bozo the Clown* show in Los Angeles circa 1960. He found Bozo vaguely terrifying. At one point, probably during a pause in taping, Bozo took questions from the kids. Wes's question dealt with the color of Bozo's costume being different than what he saw on television, not then understanding the difference between real life and gray tones on a black-and-white television set. It's curious that after fifty-five years or so Wes still resentfully recalls Bozo dismissively blowing off his question. Clown.

Left: Moona Lisa and Seymour headline at Knott's Berry Farm, 1974. *Knott's Berry Farm.*

Right: Sheriff John (John Rovick) encouraged us to laugh and be happy. *findagrave.com.*

A generation of Boomer Burbankers, wishing others a happy birthday, have spent a lifetime instinctively hearkening back to the Happy Birthday Polka ("Put Another Candle on My Birthday Cake") sung by Sheriff John (John Rovick). Some can do dead-on impressions of Hobo Kelly's Irish brogue: "H-O-B-O, K-E-double L-Y, Hobo Kelly, sure and begorah 'tis I!" And many remember haltingly drinking their glasses of milk based on red lights and green lights issued by Engineer Bill (Bill Stulla).

In the 1960s, the local kids' broadcasts were the exclusive province of the higher-number channels. In the Los Angeles area, channels 2, 4 and 7 were the major networks, CBS, NBC and ABC. First-class stuff. Channel 5, KTLA, was respected but, compared to the majors, seemed second-class. Channel 9 (KHJ), channel 11 (KTTV) and channel 13 (KCOP) were the poor parts of town. This is where the all-night movies (with the commercials starring pushy car salesmen), cheesy travelogue shows like *The Happy Wanderers* and iffy newscasts reigned supreme. Here's where sitcom reruns from the 1950s could be watched. Joe Pyne insulted his guests, and Cal Worthington sang about jalopies on the blink and let big cats scratch up his car hoods. If you remember Chick Lambert, you've spent some time watching the LA upper channels. (Chick's "Used Car Pitchman Loses It" is a YouTube classic.)

In the 1970s, ready for more grown-up fare, teenaged Burbankers enjoyed locally broadcast Saturday night horror movies hosted by Seymour (Larry Vincent) and Moona Lisa (Lisa Clarke) on KHJ's *Fright Night*. Seymour's take on his movies, audience and life in general seemed to be entertainingly sarcastic; viewers were called "Fringies." From Wikipedia: "Moona Lisa had long, straight black hair with bangs, stiletto heels and wore a black cat suit that showed much cleavage. She sat on a pile of rocks with 'moon smoke' floating around the stage. With a soft, seductive voice, she was the heartthrob of every ten-year-old boy in the city." And some teens!

An early 1970s Saturday morning feature from Los Angeles some Burbankers remember fondly was the weekly broadcast of an old Basil Rathbone–Nigel Bruce Sherlock Holmes thriller from the 1940s. The animated introduction was rather charming, with Dr. Watson descending from the air holding an open umbrella set to Henry Mancini's eerie "Experiment in Terror."

Let's Make a Deal!

This celebrated game show ran on the NBC television network from 1963 to 1968; it was filmed at the studios on Alameda Avenue. The show was famous for people dressing up in kooky outfits to get the attention of host Monty Hall, and a casting call regularly took place on the street outside the studios before taping. The following story was played out by many Burbankers: In 1968, Wes Clark's mother, hoping perhaps for the Big Deal of the Day, dressed as a sort of Huckleberry Finn character in shorts, a calico top and a straw hat. Daubing big freckles on her face with eyeliner and carrying a cardboard sign that read something like "I'm a Big Deal!," she dragged Wes out to the street where a pair of directors inspected the crowd. Mrs. Clark hopped up and down seeking to attract attention to herself. She shouted. (The more noise one made, the more attention one got, and Mrs. Clark stood second to none when it came to vocal power.) She waved her hat and cardboard sign—to no avail. Mother and son had to be content to sit and watch the show from the seats in the rear. The twelve-year-old Wes Clark remembers only two things from the shoot: (1) How amusing it was when the giant boxes were rolled around on the stage and (2) Carol Merrill's miniskirt.

BURBANK'S EVER-LOVIN' LIGHT

Where could Baby Boomer Burbankers go to see acts like the Everly Brothers, the Isley Brothers, Helen Reddy, War, Al Green, Albert King, Aretha Franklin, the Association, the Bee Gees, Blood, Sweat and Tears, the Byrds, Conway Twitty, Dionne Warwick, the Doobie Brothers, Don McLean, Edgar Winter Group, Electric Light Orchestra, Fleetwood Mac, Genesis, Henry Mancini, the Hollies, Jerry Lee Lewis, Jim Croce, Ray Charles, the Spinners, Smokey Robinson, Steely Dan, Steve Miller Band, Todd Rundgren, T. Rex, Aerosmith, Barry White, Gladys Knight and B.B. King, Ike and Tina Turner, James Brown, Marvin Gaye, Barry Manilow, Dolly Parton, Frankie Valli, Glen Campbell, KISS, Linda Ronstadt, Olivia Newton-John, Peter Frampton, Roxy Music, Diana Ross, Elton John, Heart, Tom Jones, Bread, Van Morrison, AC/DC, the Cars, Cheap Trick, Four Tops, George Benson, Hall & Oates, Ted Nugent, Tom Petty and the Heartbreakers, the Village People, Alice Cooper, the Beach Boys, Blondie, the Jacksons, Roy Orbison and many others *up close and absolutely free*?

Midnight Special tapings! The show ran from 1972 to 1981. Marvin Steinberg reports, "We would go every Tuesday night to see the taping of the *Midnight Special* at the NBC Studios; we would get the tickets in the morning at 8:00 AM and be late for school. It was amazing, being so close up and seeing everyone from the Kinks, ELO, T. Rex, Badfinger, Chuck Berry, Loggins and Messina, Bee Gees, New York Dolls, Anne Murray, Little Richard etc. Gosh, it was fun and great! Edgar Winter!!! I could go on…"

GROWING UP WITH STARS, BY JIM PEEL

I would be willing to bet that you didn't know that Sally Field [The Flying Nun] went to Thomas Alva Edison Elementary School in the early 1950s. Her stepfather was Jock Mahoney, who played the title role in The Range Rider *on television back then.…He would show up at my school in a tricked-out tan automobile with "Range Rider" in lariat written on the side, pistols for door handles and long horns on the front. Also, actress Lori Martin went to Luther Burbank Junior High School in 1959–1960. Her real name was Dawn Menzer and she was in my Social Studies class. She played in the* National Velvet *television series*

and also was the daughter in the movie Cape Fear [1962]. *DeDe Lind also went to Luther Burbank and was the "It" girl in those days. I was in seventh grade, and she was in ninth. She went on to be the* Playboy *centerfold model of the month for August 1967.*

From the Internet Movie Database entry for DeDe Lind: "Lind won the Better Baby Beauty Contest at age one. She grew up with her older sister in Burbank, California. In 1961 DeDe was discovered at a local pool in Burbank by photographer Leon Beauchemin; she was only fourteen at the time.… Lind was the Playmate of the Month in the August, 1967 issue of *Playboy*. Her centerfold garnered more fan mail than any other 1960s Playmate and thus confirmed DeDe's status as one of the single most popular and beloved Playmates from that particular era."

BURBANK CELEBRITY ENCOUNTERS, BY ROB AVERY

I trick or treated at Bob Hope's house (and so did my sons) in Toluca Lake, and my son met Bo Jackson on the Donahue *Show taped at NBC Studios—he was given a signed baseball and a signed baseball card by him. I did plumbing work in John Wayne's house and met him, and I saw Rory Calhoun in the Hughes Market near Burbank High when I was about eight or so. I also met Ray Bradbury at my mom's sewing teacher's house in Burbank when I was twelve. I met George Kennedy when they shot a four-second piece at the Story Plumbing yard for the TV pilot of* Sarge. *Finally, there was Thurl Ravenscroft, the voice of Tony the Tiger and a family friend who lived on Avon Street.*

Mike McDaniel met a number of celebrities in Burbank. Glenn Strange (known primarily to Boomers as *Gunsmoke*'s bartender) lived on Roselli Street near Mike; Mike's father was a friend of his. Other Burbank celeb encounters include Ray Walston, Jay Leno, Gordon Jump, Marie Osmond, R. Lee Ermey and Sarah Michelle Gellar, aka Buffy the Vampire Slayer.

The only celebrity encounter Wes Clark ever had in Burbank was as a kid in Zodys: Larry Storch. He looked just as oily in person as he did portraying Corporal Agorn in *F Troop*.

Burbanker Glenn Strange from *Gunsmoke*, 1960s. *Mike McDaniel.*

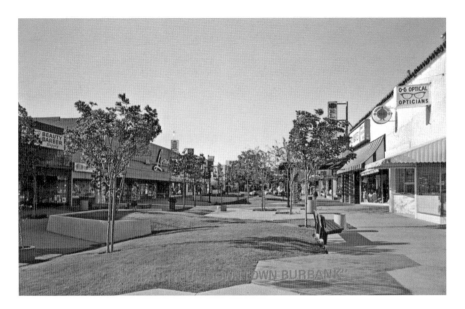

Burbank as described on *Rowan and Martin's Laugh-In*: Beautiful. Postcard from about 1970.
Mike McDaniel.

FACE TO FACE WITH THE "FBI," BY DON RAY

In 1967, we were in the long line of cars wrapped around the back parking lot at Bob's Toluca Lake when we made the turn into the alley. Some older guy drove into the same alley from Rose Street and was coming our direction on his right side. We ended up almost bumper to bumper. I wouldn't budge—nor would he. He shrugged his shoulders. I shrugged mine. Then he got out of the car and walked up to my driver's side window and said, "You're on the wrong side of the road." Being the stupid kid that I was, I said, "No, you're on the wrong side of the road." He said, "Well, one of us will have to give in, won't we?" I said, "OK, I'll move this time. Next time, you'll have to give in." "If there is a next time," he said as he turned and walked back to his car. One of the guys in my car then said, "I can't believe you would talk to Efrem Zimbalist Jr. that way." The FBI was on a TV channel we didn't get, so I didn't know who he was!

A MAGICAL APPEARANCE, BY MIKE ARREDONDO

The Ralph's supermarket on Victory Boulevard and Buena Vista Street used to have carnivals in the parking lot. The big deal then was magician Chuck Jones! Direct from KCOP Channel 13! He was performing right there! That was big time!

GLENN FORD'S FOOT, BY PATRICK THOMPSON

When I was working at a liquor store [Lil' Abner's] we would deliver to the studios in Studio City. While I was pushing a handcart piled high with cartons of vodka, Glenn Ford comes walking out of the double doors where they were filming. So rather than get all nuts by seeing him, I calmly asked, "Hey, buddy, could you hold open those doors?" He grudgingly did so, being a good sport and all, and I accidently ran over his foot. I turned, said thanks, and disappeared as fast as I could.

13

O Little Town of Burbank

Christmas, for most of America, has snow or at least the possibility of snow. This not being at all likely in Burbank, there is a degree of artificiality to the holiday that is unlike Christmas in other localities. The mother sets the emotional tone in the home, and this is never as true as during Christmas. Since Wes Clark's mother was from New Hampshire (and north of the White Mountains at that—serious snow country), she had a seasonal hunger for the white stuff and the New England look of Christmas, Southern California be damned. So she did what she could with canned aerosol snow, the white crud people sprayed on trees, windows and so on. The industrial lacquer smell of the stuff is unforgettable. To provide an olfactory drowning out of the objectionable canned snow smell, one then sprayed a can of artificial pine, which was marketed during the season. What propellants and toxins floated in the air in American living rooms every December?

An earlier chapter described Mrs. Clark's creative use of angel hair—spun glass—which served as another snow surrogate. This stuff was draped atop cabinets and put on the floor under the tree, the microscopic fibers presenting a hazard to bare feet. Getting angel hair fibers between one's toes was no laughing matter. And when warm, angel hair would mysteriously creep. People thought this was a Christmas treat, putting some across the mantel above the fireplace to watch the stuff magically expand as the season progressed. One Burbank family hung it down over the sides of the house like Edgar Winter's hair; the family thought it was fun to watch it grow.

Putting up the Christmas decorations over Magnolia Boulevard, 1976. This can be a shirt's-off activity in a Southern California winter. *Burbank Historical Society*.

The local Christmas tree merchants compensated for the absence of snow with "flocked" trees in one of Burbank's many vacant lots. But white was only one flocking option—there were also light blue and pink flocked trees available, which even in the 1960s, seemed weird. Who would want a pink-flocked tree? Zsa-Zsa Gabor? Liberace?

The City of Burbank did its seasonal part, erecting red, silver or gold tinseled decorations across San Fernando Boulevard, Magnolia Boulevard and Olive Avenue. The centers of these were ornate with stars or three electrically lit candlesticks (the tallest in the middle). The city also encouraged neighborhood Christmas decoration contests. These could be quite elaborate; one fellow living on Catalina Street has been setting out a front yard chock-full of lit and animated Christmas décor since 1970.

The Clark family's first Christmas in Burbank was in 1965. As the family was house-poor and unable to afford a big tree, Wes Clark Sr. acquired one from a co-worker at Lockheed. It was a six-foot aluminum tree with

Lockheed workers could take their kids (in this case, Wes Clark) to see Santa and receive a toy at the Lockheed Employees Recreation Club (LERC) Christmas party held at the Olive Rec Center, 1960. *Wes Clark.*

poms on the ends of the branches. What put this tree over the top was the fact that it came with *two* color wheels. The continually changing colors lit the silvery, reflective tree and the room in a phantasmagorical display, mesmerizing nine-year-old Wes.

One enterprising holiday home decorator living near the Jessup dairy drive-through on Magnolia Boulevard put something unique and so very sixties and SoCal atop his roof: a Santa in a dragster executed in painted plywood with spinning mag tires, the whole thing lit by a floodlight. Begging his parents to also capture the seasonal spirit, Wes asked for decorations of their own on the house. Mrs. Clark, always willing to indulge herself in a craft project, responded by creating a life-sized stuffed Santa Claus sitting atop a fake chimney on the front of the house and a big plastic banner of a smiling Santa hung against the garage door.

Alas! An unusual major windstorm blowing through town pushed Santa off the roof and into the street, scattering costume parts so badly Mrs. Clark gave up on putting what was left back atop the chimney. And neighborhood vandals printed a well-known two-word phrase beginning with "f" on the garage banner. What kind of greeting for new homeowners was that? And what sort of a hardened Scrooge pens *that* on a Christmas decoration? Mrs. Clark had a creative remedy, however: she took a tube of lipstick and somehow concealed the offensive lettering, modifying it into a jolly red cursive "Merry Xmas!"

There was another reason to celebrate Christmas 1965 for Baby Boomers everywhere: the first television broadcast of *A Charlie Brown Christmas*. It's now acknowledged as a beloved classic, but it's good to remember just how utterly *different* it seemed when *Peanuts* fans saw it for the first time. At first, Vince Guaraldi's jazz score sounded odd…cartoons just didn't have background music like that. And the main song, "Christmas Time Is Here," was neither jolly nor merry. It seemed minor key, introspective and subdued. And the characters' voices were by actual children, not adults, another oddity. Finally, there was the celebrated biblical passage Linus recites that Charles Schultz insisted on, a first in a cartoon. (For many kids, it may have been the first scripture they ever memorized.) Fifty years on, those grown-up kids agree that it is simply not Christmas without an annual viewing of this animated feature.

When Wes Clark became a teenager, he took over responsibility for the family Christmas decorations, and in December 1970, he duplicated some newly fashionable designs he saw elsewhere in Burbank: outlining the roof of the house in strings of red lights. The finished result was more somber than seasonal, however, and the solitary red against a black sky suggested Satan more than Santa. (The only other single-color lights in town were put up by Jewish households, and those were blue or sometimes blue and white for Hanukah.) Arranging the lights so that the bulbs stuck upright, a necessary part of the look, resulted in some damaged (and expensive to repair) asphalt roof shingles. The Clark family put up their lights like this just once more the following year (it took time and money to make those solid red strings) and then gave up trying to look leading-edge and fashionable for Christmas.

Christmas 1970 had a smell of its own, and in this year, it wasn't tree stink or aerosol snow. In 1968, Fabergé introduced Brut to the marketplace, and the killer aftershave (perfume fans call it "Brutal"), with its little green bottle and funny chained metal tag, quickly became *the* scent for men. Even Elvis wore it. So Wes Clark Sr. received a big bottle of the stuff and liberally

Above: Christmas 1970 at the Clark house: electric curlers for Mom, books for Wes and Brut for Dad (seen next to Mom's hideous puppet).
Wes Clark.

Left: Award of Merit given by the Valley Garden Club to Burbankers who went above and beyond the call of duty Christmas decoration–wise, 1967.
Mike McDaniel.

Left: A ten-year-old Wes Clark asks a visibly annoyed Louis Nye to pose for his camera at the Santa Claus Lane Parade staging area in Hollywood, 1966. *Wes Clark*.

Below: Famous boxer James J. Jeffries as Santa was assisted by Dale Evans on San Fernando Boulevard and Olive Avenue, December 19, 1947. *Burbank Historical Society*.

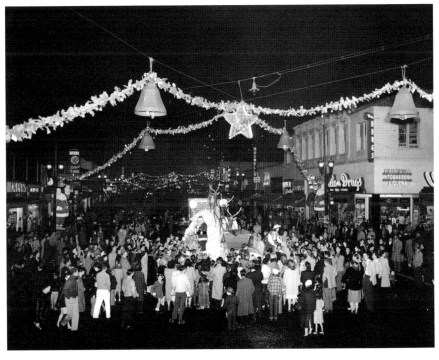

dabbed it on himself to the point where, nearly fifty years later, the smell of Brut reminds Wes Clark of Dad, Christmas 1970 and broken asphalt shingles.

There were a number of great places to shop for Christmas items in Burbank, chief among them some independent toy stores. Marv's Toys ("A World of Toys" misremembered as "Toy World") on Glenoaks Boulevard was the primo toy destination in Burbank. It sold nothing that wasn't desirable to a kid, and every neighborhood kid knew it. Marv's toys came in red and white polka-dotted bags and could be gift-wrapped in paper and bows of the same design. Kids at birthday parties, seeing this, always knew something good was inside the wrapping.

Behind the front counter at Marv's were the Hot Wheels—it looked like hundreds—all for only ninety-nine cents each. Mike McDaniel recalls his first Marv's Hot Wheels car: a maroon 1967 Thunderbird purchased by money received from returning glass soda bottles to grocery stores. Another favorite section had Schwinn bikes: Orange and Apple Krates, Lemon Peelers, Pea Pickers and other desirably exotic models. Toy stores in the 1960s unapologetically segmented aisles by gender, and there were always girls with their mothers in the Barbie doll section, shopping for clothes and accessories. The boys had a Tonka section: solid metal diggers, dump trucks and school buses with big, knobby tires. (Mike saved up $1.99 for the Tonka hot rod.) Marv's also had a huge outdoor display area next to the store, showcasing the various swing sets and playhouses for sale.

The toy section of Leonard's was a seasonal destination. In 1966, some store genius came up with an unbeatable way to promote the newly released Creepy Crawlers toy by Mattel: a table was set up and kids were allowed to pour Plastigoop into a mold to make their very own take-home rubbery insect, worm, snake, frog or spider. After that, kids just *had* to have the toy. Christmas at Unimart was also memorable. In 1967, Wes Clark got a Captain Action action figure. (In the 1960s, toy manufacturers realized that doll sales could be extended to boys by calling them "action figures" and making military gear accessories—guns and footlockers—instead of shoes and handbags. Captain Action was the superhero extension of the GI Joe idea. His accessories involved changes of costume into Captain America, the Phantom, Batman and so on.) Doll? That's no doll! That's *Batman!*

With the various seasonal television specials starring Andy Williams, the King family and others, Burbankers had no dearth of Christmas programming to watch. One of the many yuletide broadcasts on KTTV Channel 11 was the Santa Claus Lane Parade hosted by Bill Welsh. This

involved various Hollywood celebrities (some of them quite minor) shown sitting in convertible cars slowly passing down Hollywood Boulevard. Newscaster George Putnam always rode a horse. Sometimes Burbankers made the drive across the Los Angeles River and through Dark Canyon into Hollywood to watch in person. Wes Clark had fun in 1966 doing a backstage tour, gawking at the various staged automobiles and wondering, for instance, who Louis Nye was.

So while Burbank didn't have snow, it still had Christmas. And there was always Santa's Village.

14
The Burbank Experience

While this entire book is about growing up in Burbank, this particular chapter is composed of somewhat random memories of the place by Burbankers. It's a catch-all chapter for tales that do not fit neatly into any of the other themed chapters. The theme here is…*Burbank*!

Burbank in the 1950s, by Julie Grimm Gregg

We ventured out to Stough Park for picnics, to Hansen Dam for wading and down the road to the Griffith Park Zoo for an exotic adventure. I also remember the five-cent cones at Sav-On. The stately Burbank Public Library on Olive Avenue was an awe-inspiring place for a first grader, old enough to print one's name on and to own a library card. Our growing family shopped for groceries at Alexander's. Maestro Leo Damiani's orchestra accompanied our ballet performances.

De facto segregation was practiced, though we in Burbank were far removed from the civil rights movement going on in the South in the 1950s. I remember when a realtor conducted a survey on our block on Lamer Street when a mixed-race couple wanted to buy a house across the street from us (the wife was Korean). Though my parents gave their assent, the vote apparently did not go in the couple's favor, and a Caucasian couple moved in instead. For the first time I became conscious of the existence of racial prejudice.

A civic-minded Burbank youth inspects details about city council meetings, 1953. *Burbank Historical Society.*

ARNOLD MCMUNN'S MEMORIES

My father worked at Wayne Watson's Shell Service in the 1960s. A scene in the motion picture Point Blank *(by director John Boorman) was shot there. In the summer of 1964, my father came home after work and told us that he had serviced a Rolls-Royce. The automobile was carrying four well-dressed young men with long hair, and my father said that they were very well behaved. He said that he asked them were they were from, and one of the young men replied, "Liverpool."*

Owl's Drug Store became Jay Scott's Drug Store. And up the street from it on Irving was the laundromat, a Winchell's Donut Shop, a carpet and wall covering store (not necessarily at the same point in time) and Arnold's Department Store where you could buy incense, toy pop-pop boats and sundries, including Beatles and Monkees banana-flavored bubble gum cards. You could also get Sen-Sen and Fan Tan gum, Greenie-Stickum cap

A storm drain, or wash—an attractive nuisance for Burbank youth. The Burbank Boulevard overpass is in the background, 1964. *Burbank Historical Society.*

pistols and live turtles and goldfish. I think they sold James Bond bubble gum cards as well.

The San Fernando Boulevard at Delaware Road location where Ralph's currently exists was formerly a Hughes Market, which in 1959 was known as McDaniel's Market. They used a Scottish piper as a mascot. The Oscar Meyer Wiener Wagon made a stop at that McDaniel's Market one Saturday in 1960.

Shopping Bag became a Von's Market. When it was a Shopping Bag, they often gave away free samples. One summer they gave away mini ice cream cones. My brother and I got in line about ten times for that, but they still gave us the cones.

In 1959, the main building at McCambridge Park had a cigarette vending machine alongside the soda cup and candy bar vending machines! Across the street on Andover Drive, we boys used to remove the wheels from broken roller skates and nailed them to boards that we would then sit on or try to stand on as we coasted downhill—skateboards!

In the 1960s, you could buy a ticket to the Cornell Theater for fifty cents by showing your John Muir Jr. High School student identification card. And in 1965, the McDonald's across the street from the Cornell offered free Saturday matinee coupons for kids' shows such as Santa Claus Conquers the Martians *[1964].*

The TV show Rowan and Martin's Laugh-In *held a cast party on the Golden Mall. The public was invited to watch from afar. White tents containing the festivities, out of public view, were pitched on the mall. Mike Connors ("Mannix") was a guest. "Skipper Frank" Herman was the host of a kid's show on KTLA channel 5 that played* Popeye *cartoons in the early 1960s. He played Santa Claus (but was unidentified as such) at the live reindeer display that was held near Owl's Drug Store in the late 1950s/early 1960s.*

George Washington Elementary School held an annual White Elephant Sale and Carnival to raise funds. They sold items such as confetti eggs, which were whole egg shells, emptied through a hole made in the end of the eggs with care by concerned mothers so that the intact shells could then be dried and filled with confetti. The children were encouraged to buy these confetti eggs and throw them at anyone. The amusement ride at this carnival was usually a ride in the back of a DUKW (military amphibious Duck vehicle) around the playground at whirling speeds.

In 1968, local pranksters used to throw Salvo laundry detergent tablets into the fountains on the Golden Mall, causing predictable clouds of suds.

THE END OF JIM VOIGT'S LIFE OF CRIME

My life of crime ended in the late 1940s at Winstead's grocery store in Burbank. Skipping school once from Bret Harte Elementary wasn't enough. No, I had to compound my flirtation with evil by shoplifting a candy bar while in the market with my mother and little sister, Vicky. When we got home from the store, located just south of us at the confluence of Burbank Boulevard and Wyoming Avenue, I went to my bedroom and devoured the loot. Mom soon marched into my bedroom and asked, "Did you take something at Winstead's?" I 'fessed up only after she said my sister ratted on me—my word, not hers. Mom then took me back to Winstead's, where I had to fork over a quarter from my piggy bank and confess my sin to the head honcho, who limply said, "That's all right, kid. Just don't do it again." Which prompted Mom to erupt

with language I have rarely heard since: "That's it?" she yelled. "Don't do it again? You %#@$-ing idiot. You should threaten him with jail if he ever steals from you again."

We never shopped at Winstead's again. Too bad. Its candy selection was glorious.

GUNNY SACK SLIDE RIDE

There was a tall gunny sack slide that sat in a vacant lot on San Fernando Boulevard just past the Cornell Theater, circa 1966. The idea was that kids would pay their money at the base of the stairs, grab a burlap sack from a pile and climb with it to the top, where they'd slide down the slide while seated on the sack. It was a fun, fast ride down. In the summer, this was hot work. But what really sticks out in Wes Clark's mind after more than a half century is a fellow gunny sack rider who happened to be a little person. After he laboriously climbed the stairs, he wiped the sweat off his brow and panted, "All for the love of a gunny sack!," which Wes thought was hilarious.

BURBANK BOULEVARD IN THE FIFTIES, BY JIM PEEL

At the intersection of Burbank Boulevard and Victory Boulevard there was a building that was dark green, then there was (running west on Burbank) the Donut Shop which had the following written on the wall: "As you travel through this life/whatever be your goal/keep your eye upon the donut/and not upon the hole." Then there was Burbank Cleaners, Maggie's Jet (a bar where many a fight happened nightly) and Burbank Liquor.

In 1953/1954 I used to bring ice water to the (as we said then) "negroes" who worked at the Burbank Car Wash. I remember Daisy and Tommy, who were always nice to me. They would drive in every day from Los Angeles; this was back in the days when Burbank was almost exclusively white and there was a directive by some lieutenant that, after dark, all non-whites were to be stopped and questioned. Not one of Burbank's proudest moments.

Whatever happened to the business called 20,000 Guns? They had literally thousands of handguns wired to the ceiling that they claimed had been confiscated by Scotland Yard!

DRIVE-IN MOVIE THEATERS BY LEN OSTERBERG (FROM THE *SENIOR BULLDOGS NEWSLETTER*)

There were a total of two drive-in movie theaters. We had the San-Val drive-in on one side of town, and the Pickwick drive-in on the other side. This type of drive-in movie was fun for the young and the old alike, where they all had a nice, laid-back way to enjoy a movie from the convenience of their own automobiles.

Some folks overcame a money problem by sneaking extra bodies into the drive-in via the trunks of their cars. Placing three people in the trunk of a Studebaker was not uncommon in those days. However, it was a dead giveaway to any suspicious ticket-taker when a car's front wheels were not quite on the ground as it moved through the entrance. Those folks with claustrophobia were a definite no-no for this type of caper. The perfect date for a drive-in was the girl who would either get into the trunk, or hide under the dashboard without complaining.

Once a car was in the drive-in, and the trunk was unloaded, there were other problems that could arise, such as going to the snack bar for popcorn and a soda pop-ricky. There was a chance that you might notice that your car was not where you thought you parked it. This could cause the missing of the Movie-Tone News and the Bugs Bunny cartoon while strolling around the drive-in searching for one's car. There often was the added complexity for some of the audience in trying to watch a movie with one eye while playing kissy-face with their dates. Those folks from that era may still wonder what the movie Viva Zapata! *(1952) was all about. You could easily notice the folks that never saw any of the movies being shown. Their cars were parked down front and the windows were all fogged over.*

In 1972, a Burbanker could see *Super Fly* at the drive-in. *Burbank Historical Society.*

A special expensive downer came while driving away at the movie's end, when the driver side window might get torn off when some ding-a-ling would forget to put the speaker back in its place. The bent over speaker holder pole was also not a nice sight to see.

While the drive-in movie went south in history many years ago (which might have been due to the lost revenue from the petty larceny folks and the added loss of speaker poles), I am certain that most everyone who lived in those days might still have a hankering to go back in time to enjoy the old-time drive-in movie once more.

THE CORNELL THEATER ALIVE, BY W. MARTIN

Ahhh…The Cornell Theater. That was the place to be on Saturdays. We would pile into our parents' cars and get dropped off for an afternoon of movie fun. The experience started with the line forming outside, usually for a double-feature matinee. The line was a place to clown with your friends, ogle the girls and, of course, stare in wonder at the coming attraction posters on display. The lobby of the theater was a mind-blowing assault to the senses. The smell of butter-drowned popcorn tickled your nasal cavity, while the candy display case delivered the fatal blow to your wallet. With a garbage can–sized drum of popcorn, you would race to your worn-out, taped-up red felt chairs, planting your feet firmly on the fly tape–like sticky floor. The lights would dim, the camera would whir away, and the film would begin.…Truly the best days of my life. [The adhesive quality of the floor is the thing everyone remembers about the Cornell Theater. Mike McDaniel remembers that you wore two pair of pants there: one to leave stuck to the seat and one to walk home in!]

THE CORNELL THEATER DEAD,
BY MICHAEL REIGHLEY

I remember well the Cornell Theater. I also remember when they tore it down. [In 1980. It closed in 1978.] *I was working at the McDonald's across the street on San Fernando Boulevard. My friends and I were able to sneak into the old abandoned theater. We saw how water had leaked though the old dome-shaped roof and soaked the seats and sticky floors. Others had*

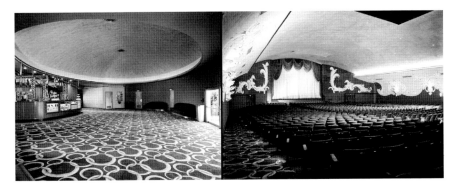

Photos taken shortly after opening in 1949, the Cornell Theater never looked better than this. *Burbank Historical Society*.

been in there as well and had torn up the big white screen. We went out to the massive lobby and saw that someone had smashed the snack bar candy display cases—glass was everywhere.

The door to the forbidden upstairs was open, and we could not help ourselves but to go up to the projection room. There we could see the old theater (that was seemingly massive) through the holes where the projectors once stood. We toured around all the nooks and crannies of the building. Behind one door were all the letters that they used on the marquee. Behind another were tickets, thousands of tickets. The Cornell was a neat place to hang out for double features when I was a kid; sneaking in food from the Shakey's Pizza "Bunch of Lunch"—a friend once brought an entire pizza! The snack bar sold pickles for a while, and sometimes they would get away from people and roll down the sloped floor only to land at your feet. I miss the single-screen theaters of those days, and I guess they are gone forever. The Cornell, though, will live in my mind forever—dead and alive.

THE SAN FERNANDO EARTHQUAKE OF 1971

Wrecks and fires are fascinating things, and many Burbankers recall a train derailment or two or a plane making its way to the airport but not ending up where it was supposed to land.

The San Fernando Earthquake of February 9, 1971, was a treat for the catastrophe-curious, and Burbankers attending John Muir Junior High School could see the local effects of the quake on their way home from school that morning. (Students, upon arrival, were gathered and dismissed

for the day by the principal.) A nearby twenty-five-foot fence had fallen onto the sidewalk; it strangely lay perfectly parallel to the concrete walk. Some distance away, a car was parked in a driveway with the house's chimney on top; the chimney had crushed the car's roof flat. Broken branches and shattered window glass littered the streets everywhere, and sidewalks had been broken up or cracked, with many lifting up like ramps. Walls had huge cracks, and much broken plaster and stucco lay on the ground.

The quake had put household pets in a state of panic, and some animals were terrified of people coming near them. (Mike McDaniel's own dog was hiding under a chair at his house before he left for school.) Perhaps the most memorable thing Burbankers saw was an apartment resident's bathroom from the street; the wall of the apartment had completely dislodged, and the entire room was exposed.

Wes Clark's memory of the earthquake mainly dealt with seeing great amounts of water sloshing out of the backyard pool and the pendulum of the living room grandfather clock banging wildly against the glass. Later that day, he and the girl across the street were standing in the middle of Lincoln Street discussing the morning quakes when an aftershock occurred; the girl screamed and ran back home. Wes recalls that standing on terra firma was like riding a wave under the pavement—very weird.

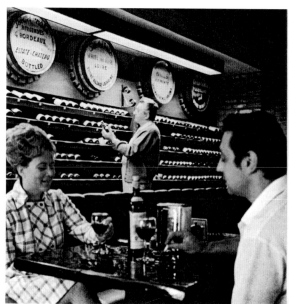

MONTE CARLO
IMPORTED FOODS AND RESTAURANT

Monte Carlo delicatessen, long known in the community for choice imported foods, has added a restaurant specializing in Italian food. Restaurant decor is a wine cellar, where you may stroll and choose from the largest selection of California and imported wines around the world at discount retail prices anywhere from 99 cents to $5.00 per bottle. No charge for corkage.

Monte Carlo is now also able to offer Italian food at its best to take out. The food, service, and prices—and Monte Carlo's newest facilities—are an unbeatable combination. Come in soon—you'll be glad you did. Open seven days a week, 9 a.m. to 8 p.m. Catering available, too.

3103 W. Magnolia Blvd., Burbank
Phone 845-3516
From Los Angeles, Phone 849-5632

A 1970s couple enjoy a meal and wine at Monte Carlo Deli. You still can. *Mike McDaniel.*

Garden Greens Grabbers, by Douglas White

During the 1970s there was a flurry of potted plant thefts in Burbank, all covered by the Burbank Daily Review. *It went on for about six months or a year, roughly the time it took to outfit a house and porch with potted plants. It was either made-up by the folks at the paper to fill space or was real. I am sure the police never searched for the culprit.*

Only in Burbank.

Sometimes You _Can_ Go Home Again

Pity the poor expatriate Burbanker! Perhaps he or she has moved away from the hometown for various reasons (often economic) and time has passed. The city of Burbank seems to have irrevocably changed, as the authors have described in the preceding chapters, and since human nature inspires a fear or dislike of change, this can be distressing. Burbank being a lot like Brooklyn insofar as sentiment and allegiance is concerned, one would like to go home again. But no less an imposing American writer than Tom Wolfe averred, "You can't go home again." Fear not! Unlike other nostalgic books that merely document old times, your authors have assembled a four-day Sentimental Journey (cue the old Doris Day hit) of Burbank that features things of old—classic Burbank experiences—that are still around to be enjoyed.

The target era is 1965–66; the Burbank activities described below are therefore all things that one could have done back then. We hope you enjoy our handy Burbank vacation-planning tool!

Warning: This trip is heavily caloric.

FIRST DAY (THURSDAY)

Fly into the **BURBANK AIRPORT** in the morning. Since the facility has been in place since 1930, this is absolutely a classic Burbank thing to do; people have been doing it for more than eighty-seven years. Be sure to take photos as you land—you may be able to catch a bird's-eye view of where you used to live.

Renting a car? We suggest a Ford Mustang. The Clark family bought one at Burbank Ford in 1965. Back then, owning a Mustang was such a unique experience that Mustang drivers used to wave at one another as they drove by. If you splurge and get yourself a convertible, you will still get stared at, we promise. And Burbank is much groovier when viewed from a drop top. Worried about the weather? (How long have you been away?)

Have lunch at **CHILI JOHN'S**. (Assuming, of course, that it's open. The hours for this place have always been subject to the whim of the owners. Call first.) That long U-shaped counter is unique. The neon clock says "Established 1900," but the restaurant has been in place in Burbank at that location since 1946. (The original store is in Green Bay, Wisconsin.) Original owner Ernie Isaac—an avid fisherman—painted that mountain lake mural you see on the wall. From the menu: "Chili John's was trademarked in 1902, making it one of the oldest trademarks in the registry, even older than Coca-Cola."

How about a leisurely afternoon game of golf at **DEBELL GOLF COURSE**? It opened in 1958. From the website: "Our municipal course is in a moderate suburb of Los Angeles, specifically in one of the media/entertainment industry hubs, so we see a broad range of clientele—pretty much the entire spectrum here." So maybe you'll see a star or two!

Your first dinner in town couldn't be more convenient: it's at **THE CASTAWAY**, a restaurant right by the golf course. From the website: "Castaway is a proud member of Specialty Restaurants Corporation (SRC). Founded in 1958 by David Tallichet, SRC is family-owned and provides customers with beautifully appointed restaurants and facilities with breathtaking panoramic views of city skylines, waterfronts and airports." We agree. The views from atop that mountain are beautiful. (If you're on a budget, you might consider the **CANYON GRILL AT DEBELL**. A little secret shared by Burbankers is that you can get Smoke House garlic bread there.)

Where's the historic place to stay while in Burbank? We recommend the **SAFARI INN**, a famous, Baby Boomer–era motel built in 1955 that is excellently preserved. The original neon sign is, as the owners suggest, eye candy. Best of all, prices are reasonable. Be sure to check out the wall next to the office that describes the many television and movie scenes shot on the site. (The Safari Inn was shown as being T.J. Hooker's home.) From the website: "The Safari Inn is well-known throughout the entertainment industry as a preferred location for several scenes in films that have included blockbuster movie titles such as *True Romance, Coach Carter, Apollo 13*, along with numerous appearances in breakthrough series such as *Six Feet Under*,

The famous Safari Inn, seen in movies and television. *Mike McDaniel.*

CSI: Vegas, Prison Break, Desperate Housewives and *Monk*. The exterior of the Safari Inn has also been used on album covers for famous rock bands such as The Wallflowers."

SECOND DAY (FRIDAY)

Breakfast is just across Olive Avenue from the Safari Inn: the **TALLYRAND**. Why was it named this? From the website: "Tallyrand began in 1959 when Al and Delores Thomas, with $5,000 in hand, opened a small coffee shop on Olive Avenue in Burbank, CA. The name Tallyrand was discovered by Al and Delores while searching for recipes in a cookbook from the St. Francis Hotel in San Francisco. They discovered a tasty soup named after the 19th Century French Statesman Charles Maurice de Talleyrand. Although the spelling has changed from its original namesake, Tallyrand's dedication to quality food has remained constant." This is a great spot for picking out Burbank regulars. The last time the authors dined here, they encountered an old friend they hadn't seen in decades.

The Talleyrand—since 1959. *Mike McDaniel.*

First activity: studio tours. While the tour itself isn't historic (you had to be somebody special to get a studio tour back when we were kids), the studios themselves are historic Burbank places. **Warner Bros.** offers a tour, giving visitors an opportunity to see the facilities where many great movies were filmed. And while you are touring the backlot on the tram, consider that Warner Bros. has a special claim to fame as far as Burbank history is concerned: Dr. David Burbank, the city founder, once had his ranch house on the property. (It is long gone.) **Walt Disney Studios** also offers a tour. You can have lunch at the Disney commissary where Walt once fired an employee he overheard making vulgar jokes about one of his animated character creations.

Your authors recommend lunch at **Giamela's Sub Shop** (established 1964). The deal here is that as long as it has the rolls for the subs, its open. When the kitchen runs out, it closes. It's a limited menu, but it's a good one. The fellow taking your order has been working there since the 1970s.

It's time to burn off that meatball sub…how about a climb up one of the gigantic old trees at the **Vickroy Park**, which was a favorite occupation of Wes Clark when he was a kid. You might even make it to the branch where

Giamela's Sub Shop. Minimum menu, maximum flavor. *Mike McDaniel.*

he carved "Wes + Viki" as a love-struck eleven-year-old of the heartless petite blonde living across the street.

Okay, let's face it, we're not spring chickens anymore; perhaps a hike along the **VERDUGO HILLS** is a better option. There was always some limited access to the hill paths in Burbank, but with the coming of more health-aware decades, the city has improved access to the trailheads and made the pathways better. The Old Youth Camp Loop is a short hike (2.6 miles, 700 feet elevation) and a reasonable workout. You can see the ruins of an abandoned and burned down camp—as well as Burbank on the valley floor below. (Trailhead address: Stough Canyon Nature Center, 2300 Walnut Avenue, Stough Canyon Avenue, Burbank, CA 91504.)

The Verdugo Hills have changed very little since we were kids; they even smell the same. But hiking them is easier than it used to be for one important reason: less smog. As a reasonably fit teen, Wes Clark hiked up the path behind Brand Library in 1972 and found himself gasping. The next day, a look at where he had hiked from his front porch made it apparent why. A brown band of smog could be seen atop the hills. You don't see that so often any more.

Some relaxing down time for the more sedentary can be enjoyed at the **BURBANK CENTRAL LIBRARY**; it hasn't changed much at all. You can still check out the 1928 edition of Herbert Asbury's *The Gangs of New York* that Wes Clark checked out in 1974. It's still there, on the shelves.

Time for dinner! And where else than the **BOB'S BIG BOY** on Riverside Drive? Teens have been congregating there for steaks, shakes and pancakes since 1949. There used to be three Bob's restaurants in Burbank; this one's the only survivor. Open twenty-four hours. Best of all, since it's a Friday night, you can enjoy the Burbank Road Kings (they still exist) and the great weekly car show. There is nothing quite like seeing the reflection of good old classic neon lighting on highly polished car surfaces—it takes you right back.

The authors suggest booking your remaining evening accommodations from an online service like Airbnb. Get yourself a stay at a typical Burbank valley floor stucco home if you can. Wes Clark did that, and it was almost like being home again in the old manse. There was a funky old metal shoe holder in a wall in the closet just like in the house where he grew up, and walking into one of those typical Burbank backyards was like stepping into a time machine. Wonderful!

THIRD DAY (SATURDAY)

Breakfast is at **MARTINO'S BAKERY**, where the justly famous Martino's tea cake can be found. Baker Amerio Corradi, with his partner Victor Martino Jr., developed the treat at the behest of a client looking for a special light and airy cake, buttery and delicious. The result has been enjoyed by legions of people for more than fifty years. An absolute Burbank classic. Guess what? They taste the same way they always have.

A pleasant Burbank mid-morning occupation is heading on down to Magnolia Boulevard to browse books at the famous **AUTOBOOKS-AEROBOOKS** store ("The World's Fastest Bookstore!"). Opened in 1951, this store specializes in books about automobiles and aircraft. Whether it's Buicks, Bentleys, Lockheed Blackbirds or Boeings, there's a book here about it! Saturday mornings feature "Cars & Coffee" events when people bring their interesting rare cars and chat with other car buffs. Jay Leno is a frequent visitor; you might see him with one of his fabulous vintage cars.

Think Italian. Lunch is at another famous Burbank submarine sandwich shop, **SANTORO'S** on West Burbank Boulevard. It's been in business since 1956 and was named after the original owner, Pat Santoro. The meatball

The Aerobooks-Autobooks store, open since 1951. Looking for a book about a plane or a car? It's here. *Mike McDaniel.*

Santoro's Sub Shop, a favorite with locals. *Mike McDaniel.*

sub is tremendous. Another good choice for Italian is lunch at the **MONTE CARLO DELI/PINOCCHIO'S RESTAURANT** on Magnolia Boulevard. The website says that it was established in the 1960s, but if you examine the wine bottle corks used as wall decoration, you will see the year 1966. The corks, wine casks and World War I airplane prints have been there since then. The Monte Carlo Deli is where some great Italian haggling and conversational action takes place. The various Pinocchio puppets are still all over the place.

If the thought of staring another meatball sub in the face makes you queasy, you might consider a healthier option at the **FULL O' LIFE** on Magnolia Boulevard. Opened in 1959, this place was natural, organic, vegan, hormone-free, additive-free and healthful long before the terms became popular.

For the afternoon the authors suggest **"DOING THE BOULEVARD"** (**MAGNOLIA BOULEVARD**). Back in the 1960s, most of the shops along Magnolia were antiques stores. Nowadays, the antiques stores have given way to trendier goods like comic books and vintage clothing, but it's still a pleasant blast from your past, except set with a modern retro vibe. What's old is new again.

Here's a cheap retro treat the locals are aware of: stop in the Rite-Aid drugstore on the corner of Hollywood Way and Magnolia Boulevard and have a **THRIFTY ICE CREAM CONE**, just like you used to do fifty years or so ago. Even the flavors are still the same. The authors recommend the chocolate malted crunch.

But you might spoil your dinner doing this. Who cares? You're on vacation. Dinner is at **SHAKEY'S PIZZA** on San Fernando Boulevard near where the Cornell Theater used to be. Same Shakey's, same pizza. Which is still delicious, by the way, just as it was back in the sixties. It's fun to look at the familiar old advertisements on the walls. Or, if you are Italian-ed out from Pinocchio, try dinner at the **SIZZLER** on Hollywood Way. It's still there.

If you are visiting Burbank in the fall, in the evening you might catch the **BIG GAME**, the annual football game between crosstown rivals Burbank High School Bulldogs and John Burroughs High School Indians. (Yes, they are still Indians.) Held since 1949, it is the preeminent Burbank sports event. It grieves your Bulldog authors to report that, since 1949, when the first game was held, Burroughs has won forty-two games to Burbank High's twenty-six.

Is it summer? Perhaps there's a performance of some kind going on at the **STARLIGHT AMPHITHEATRE** (**"BOWL"**). That's a venue that hasn't changed much over the decades. The structure was built in 1950, but Burbankers have been going to the site to hear concerts since the 1940s.

They used to sit on logs.

If you are visiting Burbank in December, drive around and look at the **CHRISTMAS LIGHTS**. Some homes still look exactly as they must have looked in 1965, sporting the very same 1960s-style white, blue, green, red and orange incandescent bulbs.

FOURTH DAY (SUNDAY)

Breakfast on your final day in town is at **LANCERS**, a longtime Burbank establishment doing fine, thank you very much. Lancers used to be known as Page's Pavilion and had a somewhat oddly executed medieval theme. It was styled to suggest the high Middle Ages—except with the vibrant reds and oranges of the 1960s.

It's Sunday. Are you a religious person? There are many churches in Burbank, and most of them haven't changed much from when we were kids. The **VILLAGE CHURCH** on Victory Boulevard is still going strong and, yes, that ancient green neon sign is still there. **ST. FINBAR CATHOLIC CHURCH**, established in 1938, is also still holding mass and thrives. Stepping into the

The Village Church. Is this the oldest neon sign in Burbank? *Mike McDaniel.*

church and seating himself in a pew reminded Wes of his favorite hymn, "Holy, Holy, Holy," being thundered by the organ and congregation when he was twelve. Mike McDaniel worshipped at the **LATTER-DAY SAINT (MORMON) CHURCH** on Sunset Canyon Drive. While it's the same building as the old Country Club, in 1986, a major interior redesign took place. So it's the same, yet different.

Or, if you aren't the church-going type, play some basketball or softball at the **OLIVE** or **MCCAMBRIDGE RECREATION CENTERS**. They have been around longer than you have, most likely. The Olive Rec Center was constructed during World War II for military personnel.

Lunch today is at the **CORAL CAFÉ**, established in 1957. The food is still great!

A relaxing Sunday destination is the magnificent **BRAND LIBRARY** in Glendale. Yes, Glendale. But it is geographically close to Burbank: just follow Sunset Canyon Drive east. Brand Library has an incredible collection of music and arts holdings, as well as a cool little art gallery. Back in the 1960s and 1970s, you could listen to vinyl records by the Beach Boys, Lou Reed and David Bowie in the recordings room at Brand. Amazingly, you still can.

Is there an evening play or performance going on at the **BURBANK HIGH SCHOOL AUDITORIUM** or the **LUTHER BURBANK JUNIOR HIGH SCHOOL AUDITORIUM**? Both interior spaces look exactly the same as they did in the 1950s and 1960s. If you actually went to one of these schools, it's an especially evocative blast from your past. (To be fair to Burroughs alumni, it appears that their school has become the center for musicals and plays, so it's more likely you'll end up there.)

Dinner is at the **SMOKE HOUSE**, which has been serving great food (and extraordinary garlic bread) since 1946. We recommend the prime rib. As with some other Burbank sites, you might see a celebrity or two here. Or if you want to go cheap, how about **LARRY'S CHILI DOGS** on Burbank Boulevard? They've been a business in Burbank since 1952; their signage is original. They used to be across the street, but it still looks, tastes and feels like it always has.

Another good option is **TONY'S BELLA VISTA RESTAURANT** on Magnolia Boulevard. It opened in 1950. This place has always had a great old-fashioned Italian restaurant vibe; it's a favorite Burbank dining spot.

You'll have to gas up the rental Mustang before returning it. Do this at the **UNION 76 GAS STATION** on the corner of San Fernando Boulevard and Buena Vista Street. The station has changed brands, but that building is the same and it's still a somewhat lonely, scary spot at night, just as it

was back in the 1960s and 1970s when it used to get held up all the time. Back then, the place used to cash payroll checks, so it was an obvious target for crime. That intersection used to be what the Brits would call a "dodgy neighborhood."

Now that you are at the end of your nostalgic tour it's time to wind down and reflect. Head up to the **STARLIGHT BOWL PARKING LOT** and take in the lights at what used to be Burbank's finest Inspiration Point. You might have to walk to it because now the lot is usually kept locked—be wary. The last time your authors visited this site there was a pack of wild coyotes roaming around there.

The lights of Burbank are much as they always were when you were a kid. This little poem by an author famous for other things seems an appropriate way to end our sentimental journey:

My childhood's home I see again,
And sadden with the view;
And still, as memory crowds my brain,
There's pleasure in it too.

O Memory! Thou midway world
'Twixt earth and paradise,
Where things decayed and loved ones lost
In dreamy shadows rise,

And, freed from all that's earthly vile,
Seem hallowed, pure, and bright,
Like scenes in some enchanted isle
All bathed in liquid light.

Abraham Lincoln, 1844

Bibliography

Books

Burbank High School. *The Blue and White Wave High*. Burbank, CA: Burbank High School, 2008.

Burbank Unified School District. *A History of Burbank*. Burbank, CA: City of Burbank, 1967.

City of Burbank. *Burbank Centennial History, 1911–2011: Celebrating Our Past and Embracing Our Future*. St. Louis, MO: Reedy Press, 2011.

Clark, Wesley H., and Michael B. McDaniel. *Lost Burbank*. Charleston, SC: The History Press, 2016.

Mayers, Jackson. *Burbank History*. Burbank, CA: James W. Anderson, 1975.

McDaniel, Michael B. *Burbank Veterans Memorial Book*. Burbank, CA: self-published, 2015.

Michel, Renée Sharlene. *Michel's Record City*. San Francisco: Blurb.com, 2014.

Monroe, George Lynn. *Burbank Community Book*. Burbank, CA: A.H. Cawston, 1944.

Perry, E. Caswell. *Burbank: An Illustrated History*. Northridge, CA: Windsor Publications, 1987.

Rich, Ben R., and Leo Janos. *Skunk Works*. New York: Little, Brown and Company, 1994.

Schonauer, Erin K., and Jamie C. Schonauer. *Early Burbank*. Charleston, SC: Arcadia Publishing, 2014.

Strickland, Mary Jane, and Theodore X. Garcia. *A History of Burbank: A Special Place in History*. Burbank, CA: Burbank Historical Society, 2000.

Pamphlets and Booklets

Burbank Senior High School. *BHS 70th Memories*. Burbank, CA: 1978.
City of Burbank Public Information Office. *City of Pride and Progress*. Burbank, CA: City of Burbank, 1981.

Websites

Burbankia. http://wesclark.com/burbank.
BurbankNBeyond. "The Big Game." http://www.burbanknbeyond.com.
Starlight Bowl. http://www.starlightbowl.com.

Index

About the Authors

Wes Clark was born in Los Angeles but his family moved to Burbank when he was eight; he was educated mostly in Burbank schools. He met Mike McDaniel in 1972, and they graduated from Burbank Senior High School in 1974. They have always been intensely interested in history. Clark lives in Springfield, Virginia, with his wife of thirty-seven years—they have three kids and six grandchildren. An electrical engineer, he works for U.S. Patent and Trademark Office in Alexandria, Virginia. His website is wesclark.com. Retirement beckons.

Mike McDaniel was born at the Burbank Community Hospital (now gone) and has lived in Burbank in the same house for sixty-two years. He was educated in Burbank Schools. Mike has been married for thirty-eight years; he and his wife have five children. Mike has worked for the City of Burbank for thirty years and is the supervisor of the City Print Shop (printing being a vocation he learned in high school). Retirement beckons there, too.

Left: Wes Clark as a Cub Scout in 1966. *Right*: Mike McDaniel, Christmas 1965. *Wes Clark and Mike McDaniel.*